AMERICAN ART & ARTISTS

Series Editor: BRENDA GILCHRIST

JOSEPH STELLA

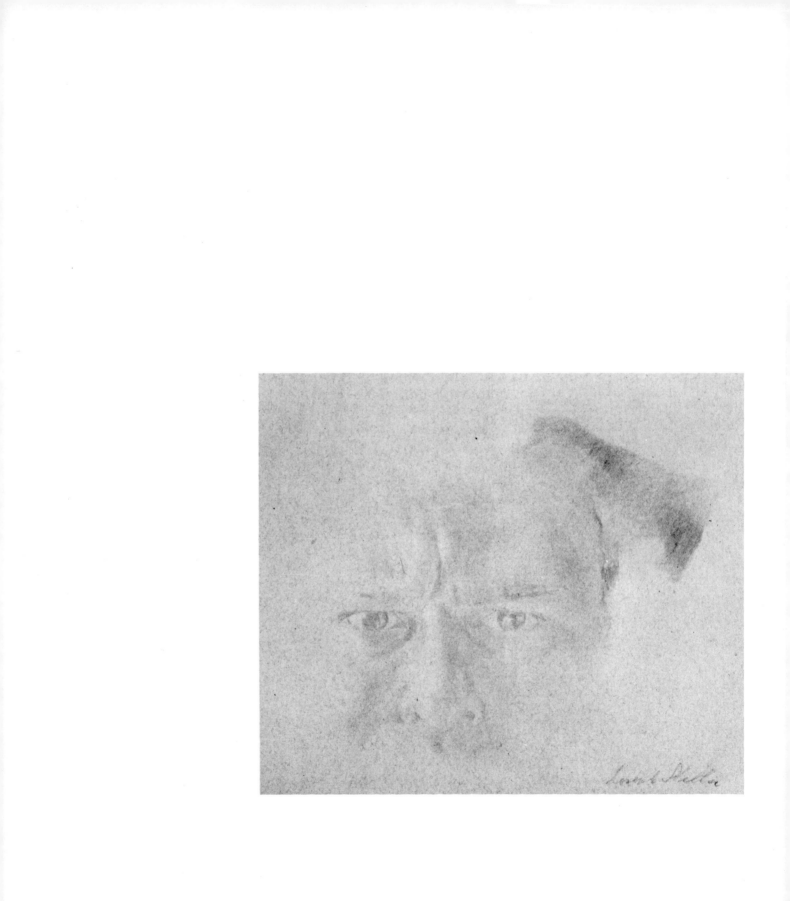

JOSEPH STELLA

JOHN I. H. BAUR

RESEARCH BY IRMA B. JAFFE

 PRAEGER PUBLISHERS

NEW YORK • WASHINGTON • LONDON

FRONTISPIECE. *Self-portrait. Ca.* 1907. Blue pencil. 6 x 6¾ inches.
Rabin and Krueger Gallery, Newark, New Jersey.

PRAEGER PUBLISHERS
111 Fourth Avenue, New York, N.Y. 10003, U.S.A.
5, Cromwell Place, London S.W.7, England

Published in the United States of America in 1971
by Praeger Publishers, Inc.

Library of Congress Catalog Card Number: 74–125486

Printed in the United States of America

For Pompy

CONTENTS

LIST OF ILLUSTRATIONS

PREFACE AND ACKNOWLEDGMENTS

The aim of this book is to present, on a more comprehensive scale, a somewhat balanced group of illustrations covering the varied phases of Stella's career and to provide a much fuller study of his life and work than was possible in the exhibition catalogue of the retrospective exhibition of Joseph Stella's work at the Whitney Museum of American Art. It must be admitted that the word "balanced" is used in a subjective sense, for Stella was uneven and it has seemed advisable to represent certain aspects of his work scantily and one or two not at all. Future taste may, of course, reassess these aspects.

Dating Stella's works and the events of his life poses an almost insuperable problem. Even his birth date is in question; he himself gave conflicting years, and the one adopted here has simply the weight of greater probability. The chronology of his works is still more difficult. He seldom dated his paintings, and even when he did the dates are not always correct. A small *Study for Battle of Lights, Coney Island (Ill. 35)*, for instance, is dated twice on the canvas, 1914 and 1915, but there is strong evidence that it was done earlier. After 1919, stylistic evidence is not of much use, because Stella periodically revived his earlier styles and often worked simultaneously in several conflicting manners. Two examples of the problems faced may suffice. In the case of the collages, not one of which is dated, we have assigned an approximate date only to *Collage Number 4, The Bookman (Ill. 70)*, which was reproduced in *The Little Review* in 1922 and was presumably done shortly before then. Since it is known that Stella worked in collage through the rest of his life, it is impossible even to guess at the years of the other examples. In the case of the wax-crayon botanical studies, however, several are dated—always (so far) in 1919. Since there is no compelling evidence that Stella did these at a

later period, the undated examples have been placed at about the same time. But obviously they *could* have been done later, and a strong *caveat* must be issued on all our "circa" dates. A final warning on titles. Stella seldom inscribed these on his works, and, except in the case of his major paintings, the majority used here are arbitrary and descriptive ones.

It is impossible to thank all of the many people who have helped with the preparation of this book, but my first and greatest debt of gratitude is to Irma Jaffe, who did the major part of the research, made available to me the large body of documents she had gathered on Stella in preparation for her doctoral dissertation on the artist, compiled the Bibliography and Chronology, and aided in countless other ways. The whole project owes much to her generosity and scholarship. We are both indebted also to Marie Lenfest Schmitz, who did the first serious research on Stella for her master's thesis at Columbia University.

Sergio Stella, the artist's nephew, has given invaluable aid in making available documentary material and the large collection of Stella's work owned by him and the artist's estate. An almost equally extensive collection is owned by Rabin and Krueger in Newark, and I am most grateful to Bernard Rabin for giving us free access to this, for providing us with the names of collectors to whom he had sold outstanding works, and for permitting these to be examined and photographed at his gallery. Three other dealers who have done much to revive an interest in Stella's work were most helpful: Edith Gregor Halpert, Robert Schoelkopf, and Virginia Zabriskie. Among the many individuals who contributed to special phases of this study, I would like to thank particularly Ina Carlin, Norman Linde, August Mosca, Mrs. H. W. Nice of the Barbados Museum and Historical Society, and Dr. and Mrs. Leonard M. Weinstock.

I owe a special debt of gratitude to Patricia Westlake of the Whitney Museum for her help with the manuscript and for compiling the index.

Finally, I am most grateful to the many collectors and museums who permitted their works by Stella to be reproduced here. The Newark Museum, which gave Stella a one-man exhibition in 1939, was particularly helpful, and I would like to express my thanks to its former curator William H. Gerdts for his aid and interest. George Heard Hamilton and Andrew C. Ritchie of the Yale University Art Gallery were also most generous with their cooperation.

John I. H. Baur

JOSEPH STELLA

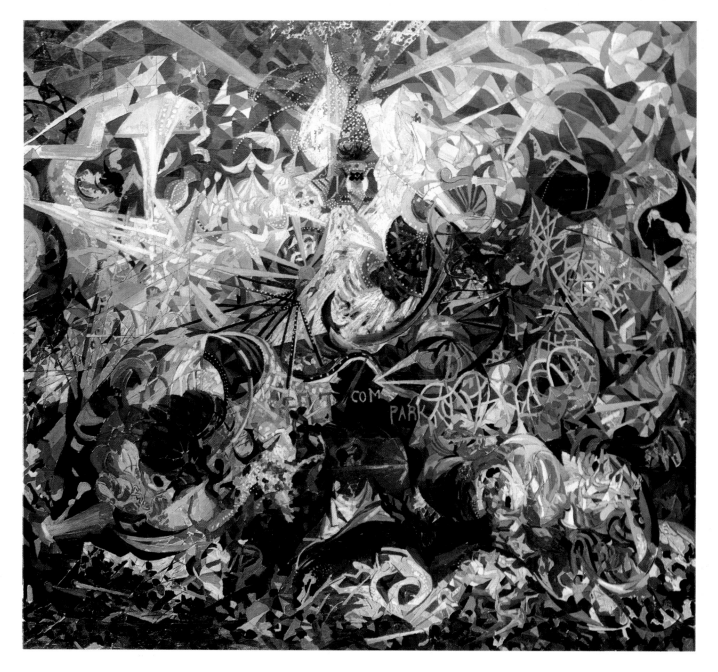

PLATE I. *Battle of Lights, Coney Island*. 1913–14. Oil. 75¾ x 84 inches.
Yale University Art Gallery, New Haven; Collection Société Anonyme.

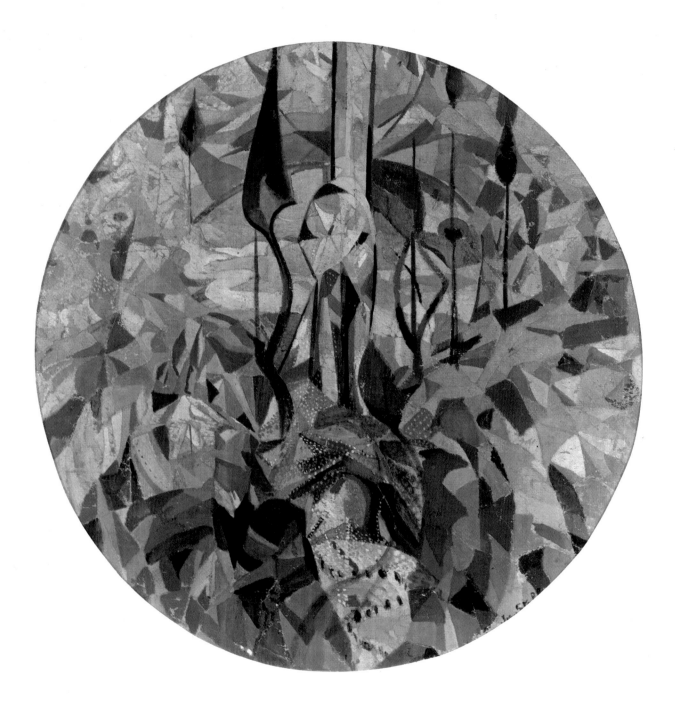

PLATE II. *Coney Island. Ca.* 1917–18. Oil. 41¾ inches in diameter.
The Metropolitan Museum of Art, New York; George A. Hearn Fund, 1963.

INTRODUCTION
THE ART OF JOSEPH STELLA

Since his death in 1946, Joseph Stella's reputation has rested principally on his lonely eminence as America's first and leading Futurist, indeed, our only one of significant stature. He was, in fact, both less and more than this: less because his connection with the Italian Futurist movement was tenuous at best and his truly Futurist canvases few; more because his restless, romantic talent led him to explore a greater range of different and apparently contradictory directions than most artists attempt.

That these other directions have been so largely forgotten (except by a small group of devoted friends, scholars, and collectors) is not surprising. For one thing, Stella seldom pursued them to ultimate conclusions and often failed to crown them with a work of summation, a work of commanding presence that would proclaim his mastery of them. For another thing, some of his directions were in themselves sterile, at least by today's standards: the excursions into sentimental allegory and symbolism, the eclectic religious paintings and profile portraits, the occasional use of cloying or garish color, the descent into coarseness and carelessness in certain late works. Perhaps only in George Grosz is there the parallel of an artist endowed simultaneously with such genius and such complete lack of "taste"—in both cases the product of a romantic, totally unself-critical nature.

But taste has little to do with greatness; it is the prop of the minor artist, the least concern of the innovator. The very exuberance that led Stella down unprofitable paths and stopped him short of masterpieces in some of his experiments was also his strength. To his ebullient spirit nothing was impossible; the conventions of art (and life), the usual processes of orderly stylistic development were meaningless. "From 1921 on," he wrote in his *Autobiographical Notes,* "I was swinging as a pendulum from one subject to the

opposite." And again: "I complied without any reserve with every genuine appeal to my artistic faculties . . . trampling those infantile barricades [of the] self-appointed dictators infesting the art fields."

With a truly awesome vitality, Stella moved from style to style, from realism to abstraction to surrealism, forward and back, mixing media, painting simultaneously in different manners, reviving older styles and subjects years later. The result is a nightmare for the art historian, but out of all this disorderly creation there emerged a handful of truly impressive paintings and a very large body of other works that are equally fine within their less ambitious scope. Among these are some that seem to pioneer, almost casually, almost accidentally, certain important directions in twentieth-century American art.

One ground for Stella's self-confidence as an artist must surely have been his early and natural mastery of drawing. As a child in Italy, he had drawn continuously; before he was twenty, he was as proficient as many a mature artist; and by 1905, when his first published drawings of immigrants appeared in *The Outlook*, under the title "Americans in the Rough," he could draw anything. These studies and the multitude of drawings that followed over the next six or seven years are singularly free from "manner." They use none of the conventions taught in schools—no blocking in of masses, axis lines, simplifications of shape, or summary methods of suggesting effects. Precise, carefully shaded, they analyze form and texture with a nearly microscopic exactitude. Their kinship (in the figure drawings particularly) is more with the old masters than with the work of contemporary artists. It is only in certain landscapes and industrial scenes that an element of style appears, a kind of dark impressionism that may have been as much the result of Pittsburgh's murky atmosphere (where many of them were done) as it was the influence of William Merritt Chase, with whom Stella briefly studied. In any case, the early drawings as a whole are a remarkable achievement for so young a man; in sheer technical brilliance they surpass anything of the kind in America at the time.

Stella's first paintings—the few that have survived—show a nearly equal facility, but they are more conventional and more plainly influenced by Chase's bravura brushwork, dark palette, and painterly handling. Through Chase and Henri a whole generation of American students learned to venerate Hals, Velázquez, and Manet, and Stella was no exception. Soon he transferred his admiration to the Renaissance masters, read Cennino Cennini, and experimented with glazing, as in his *Italian Church (Ill. 24)*. But it was not until he reached Paris in 1912 that Stella began to mature as a painter. The catalyst was modern art. He met Matisse and Picasso, was a close friend of Modigliani.

He looked at the work of the Fauves and the Cubists, and painted (rather conservatively, in view of his enthusiasms) a series of patterned still lifes in pale blues, pinks, and muted whites, which owe more to Bonnard than to the more daring men.

At the same time, Stella must have memorized with great vividness the works that he saw at the Futurist exhibition at Bernheim-Jeune's in 1912 (where we know he met Carrà). Back in America he began, in the spring of 1913, his first big Futurist canvas, *Battle of Lights, Coney Island (Plate I)*, a painting that suggests strongly the influence of Severini in its carnival subject and its serpentine motion, in which fragments of observed reality are whirled about. Other aspects of Severini's work, such as his pointillism and his lively triangulation of space, continued to influence Stella for several years, particularly in a series of paintings and pastels devoted to the theme of *Spring*. But neither in these nor in the earlier work could he be called an imitator, for the forms and the complex designs were very much his own. And in his next two major works, *Brooklyn Bridge (Plate V)* and the five big panels of *New York Interpreted (Ills. 66–69 and Plate VIII)*, Stella departed so far from his Italian confreres that it is a question whether these works should be called Futurist at all. In a sense, he outdid the Futurists at their own avowed aim of glorifying the mechanistic aspects of modern life. Actually, they seldom painted such themes, whereas Stella found in New York their perfect embodiment. "New York is my wife," he told Charmion von Wiegand, and continuously in his writings he paid homage to the "towering, imperative vision" that it imposed on him. In painting it, however, he largely abandoned the dynamics of Futurism, its restless insistence on motion. He preferred to give his subject greater stability, and while he continued to work with semi-abstract designs of recognizable elements arbitrarily combined, the only motion is the rising one implied by the repeated verticals. His city soars but it has the solidity of steel and stone.

During the same decade (1913–23) that Stella was painting his major Futurist canvases, he was also painting the city in much more realistic, though simplified, form. These pictures of buildings, gas tanks, factories, and smokestacks, which seem to have been done from about 1918 on, are among the earliest in our art to proclaim the intrinsic beauty of modern engineering. Moreover, their style of sharp contours, smoothly modulated volumes, and generalized forms forecasts astonishingly the so-called Immaculate or Precisionist movement, which emerged slightly later. It was not a direction that Stella chose to pursue at any length, and he probably had little direct influence on Charles Sheeler, Niles Spencer, or our other leading Precisionists, but he

appears to have antedated them all by at least a few years.

The brief period 1919–20 was one of extraordinary productivity and experiment in Stella's career. Not only was he working on his Futurist and Precisionist paintings, he was also turning his hand to botanical studies, to collages, and to the first of his large symbolic canvases. Of these, the botanical studies offer the most striking contrast to his modernist vein. Done on paper, in wax crayon for the most part, they are brilliant in color and painstakingly realistic in detail. At first sight, they remind one of the beautifully precise and decorative flower prints in eighteenth-century botanical treatises, but many of them go beyond this into a realm of fantasy that borders on the surrealist. The sliced section of a pomegranate looks subtly visceral, the stem of a sunflower writhes like a snake, a squash takes on the deliberate semblance of a swan. Everything is stated with exactitude; nothing is quite what it seems.

The collages are at an opposite extreme. Completely abstract, they appear to have sprung from Stella's delight in pure texture and color, and particularly in the accidental effects of natural causes. He called them his "Naturelles," and they are largely constructed of irregularly torn fragments of dirty cardboard and paper, water-stained, smudged, marked by the tread of automobile tires or passing feet. In their utilization of "junk," they bear a fortuitous relation to the *Merz* collages that Kurt Schwitters was beginning to do in Germany at the same time. But they are even further removed in form and spirit from the tradition of Cubist collage. For while Stella occasionally used clippings of printed matter or rectangles of colored paper, nearly all his work in this medium has a kind of inspired casualness, an accidental, informal quality very different from the analytical designs of Cubism. Indeed, they forecast, quite uncannily, the look if not the feel of certain Abstract Expressionist art of a later date, such as the collages of Robert Motherwell.

Several pastels dated 1918 (*A Child's Prayer* [*Ill. 48*], *Song of the Nightingale*) announced still another direction in Stella's art—his penchant for symbolism. At first this took purely abstract form: The prayer is embodied in ascending curves against vaguely churchlike shapes; the song is plotted as a looping graph. In this approach, Stella may well have been influenced by another American modernist, Arthur G. Dove, who even earlier had done a series of abstract pastels symbolizing such things as the forces of nature or the motion of a team of horses. But in his first large symbolic oil, *Tree of My Life* (*Plate IV*)—which is filled with recognizable if arbitrarily composed foliage and birds—Stella began to retreat from abstraction. And in his later symbolic canvases the imagery became more concrete and, unfortunately, more lushly sentimental. Only a few of these, like *The Amazon (Ill. 78)*, which symbolizes

modern American woman, are saved from bathos by a kind of wildness of imagination, an almost surrealist fantasy.

This surrealist quality—if one may call it that—informs much of Stella's best work during the last twenty-five years of his life. The most notable paintings of the period are his tropical fantasies, inspired by several trips to North Africa and one to Barbados. The luxuriance and exoticism of the tropics were in profound accord with all that was romantic and visionary in Stella's nature. His response was almost frightening in its intensity as he heightened color, exaggerated size and proportion, piled profusion on profusion. At the same time, he imposed on this riot of fecundity a nearly emblematic order: The canvas is generally divided by a strong vertical, on either side of which the two halves match with almost mirror-image exactness. Sometimes the central axis has phallic connotations, and in such cases surrealist, or at least subconscious, motivations may be justifiably inferred. But in general, the effect is quite different and perhaps even stranger. It might be called mystery symbolized, a contradiction that probably succeeded simply because the mystery engulfed the symbolism—just as Stella's sheer vitality so often and fortunately overrode his concepts.

The later years of Stella's life were not by any means devoted exclusively to tropical subjects. He painted numerous still lifes, in which a variety of rather tawdry objects (including a plaster devotional statuette) were transformed into well-knit, richly painted compositions of considerable strength. He also produced great numbers of landscape studies in pastel and watercolor, some of which are pleasant enough, only a few of which (like the stark *Cypress Tree* [*Ill. 79*]) are in any way exceptional. And throughout these years he drew constantly, prolifically, carelessly; too often the later figure studies are coarse notations in a heavy, overemphatic line; they seem like caricatures of his masterful early drawings with their incisive analysis of form and texture.

More rewarding was Stella's frequent re-exploration of the major directions of his youth. While he never returned to the purely Futurist style of *Battle of Lights, Coney Island* or *Spring (Plates I and III)*, he painted several impressive later canvases of bridges and industrial themes in the Futurist-related manner of *New York Interpreted (Ills. 66–69 and Plate VIII)*. He also continued to work, with sustained brilliance, in collage, and possibly on his wax-crayon botanical subjects. (A stylistically related *Tropical Bird* [*Ill. 95*] in the same medium is inscribed 1940.) While no startling innovations appeared in Stella's work after the early 1920's, his later career was far from unfruitful.

The complete Stella remains, as perhaps all good artists must, an enigma

compounded of widely conflicting elements. How the traditionalist of the early drawings attained, at one leap and with almost no visible transition, the mastery of an advanced abstract idiom is remarkable enough. How the aesthetic sensibility that shaped the collages could also delight in *The Apotheosis of the Rose* is even more baffling. Such contradictions and stylistic gyrations abound in his work, without apparent explanation other than the romantic exuberance of his nature. Certainly to Stella no conflict was apparent. Everything he did was uniquely valuable, and the key to its value was beauty—a word of which he had no fear.

"God bless you," he said to his friend August Mosca in his final illness. "I will get better, and we will have a studio together where we will paint beauty again."

"That night," Mosca recalled, "he died—his nephew said quite quietly."

PART ONE
THE OBSERVER

Heavy-set, about five-foot-nine, rather round. Square-jawed, with deep brown eyes, almond-shaped. Always carried a cane and wore a muffler except for the two hot summer months. Jammed his beaten-up fedora squarely on his head. Small neck, but thick. Sparse hair which he always had cut close to his skull. Ate prodigiously. . . . Never drank much liquor except wine or beer. . . . His dress very odd, a rope or string for a belt. Sometimes he would wear suspenders, but only when going to a formal reception or party. . . . He was intensely proud and fiercely independent . . . subject to sudden rages when he would roar so that he could be heard for a couple of blocks away. And just as suddenly he would get sentimental and croon like a mother over her child. Almost anything could get him upset. . . . He never liked to be alone. Always he loved the noises of the city—his studio on 14th Street was his favorite because he loved the daily and constant procession of people and autos. He felt he was living when there were people and talk and laughter around him. His favorite sitting position was with his chin on his hands, holding his cane. And always he loved to talk.

This was Stella at the end of his life, as his friend August Mosca remembered him. Of his youth we have only his own recollections, colored perhaps by sentiment and the passage of time, but vivid enough to be accepted in outline, if not always in detail.

"I was born," he wrote, "in Muro Lucano, Basilicata, now Lucania, in the south of Italy—the 13th of June, 1877." This is the date he gave in several versions of his *Autobiographical Notes* as well as in his naturalization papers. At other times, he listed the year of his birth as 1879 or 1880, but this seems to have been a deliberate act of rejuvenation.

It was a blessing [he continued] to be born in a little town where life is still primordially composed of essentials and luxury of any kind is unknown.

The people seem to spring from the ground like plants, and the houses derive like natural, logical growths from the red, dry earth that bounds the [harsh] rocks which build and construct the mountainous landscape. The stony houses are mostly one or two floors high, some whitewashed with pure lime. . . . They are grouped together on a rock, one on top of the other, and they have the form of a family grouped together [so] as to be protected by each other against any menace of elements and people alike. On top, a solidly constructed [medieval] castle, where Queen Giovanna was killed, arises.*

Stella was the youngest of five sons; his father, a lawyer. From childhood he loved to draw, and one of his first paintings, depicting the miracles of a local saint, is reputed (by Stella) to have been carried in procession to the local church and hung in a place of honor. Perhaps he had it in mind when, at a much later date, he reflected: "True art cannot spring but from naïveté. Everyone has been a child, and the true artist is the one that has preserved intact all those treasures of great sensitivity felt in their early childhood. . . . Time goes on, but the first songs ever sung by nature always sing on in his soul."

Like his brothers, Stella had a classical education, which he completed in Naples when he was eighteen. By then his father and brothers had emigrated to the United States, and he followed them in 1896, arriving on the first of March. In New York he lived for a time on the Lower East Side near the Bowery, supported by his brother Antonio, who had become a doctor with a large clientele of immigrants (although he later numbered Caruso and Charles Evans Hughes among his patients). It was doubtless at Antonio's urging that Stella studied medicine and pharmacology, each for about a year, before he finally embarked on art as a career.

Stella's formal training as an artist was brief, probably not more than three years. He was enrolled at the Art Students League in 1897. Soon, however, "I joined the New York School of Art, and after one year . . . I gained the scholarship for the free tuition of another year." There he won the commendation of the school's founder, William Merritt Chase, who propped one of

* This and subsequent quotations of Stella's own words are from one of several unpublished manuscripts labeled *Autobiographical Notes,* unless otherwise indicated. Another manuscript, entitled *Notes about Joseph Stella,* should probably be included with the above; it is written in the third person, but the language suggests that it may have been composed by Stella himself. Spelling, punctuation, and grammar, for all of which Stella had a fine disregard, have been partially corrected when necessary for coherence. Otherwise I have not tampered with his very personal ornate style.

Stella's portrait studies before the class and told it, "Manet couldn't have done it any better." And, indeed, judging by such early paintings as *Nude* and *Laughing Man (Ills. 3 and 4),* Stella learned quickly the Chase technique of a direct attack on the canvas with a heavily loaded brush, the swinging marks of which create a look of rapid spontaneity. In addition to Manet, Hals and Velázquez were the models Chase held up to his students, and the influence of the Dutch master is quite apparent in the *Laughing Man.* While these paintings still bear the stamp of school work, they also demonstrate the ease with which Stella, from the beginning, acquired technical fluency.

Stella's mastery of technique is even more apparent in his early drawings, which contain no hint of classroom conventions. For one thing, their subjects were drawn from life, not from the studio: They are the people Stella saw around him on the Lower East Side, the workmen, the derelicts, the immigrant mothers with their children. In his predilection for such themes he may well have been influenced by Walt Whitman, whom, with Poe, he greatly admired. It is also possible that he may have known the work of Jerome Myers, who had painted the slums as early as 1887, or that he had some contact with the group known later as The Eight, several of whom were beginning to explore the same field at about the same time as Stella. In any case, it was still an unusual theme for a young artist to broach in the climate of academic gentility that prevailed in America at the time.

In 1905 some of Stella's drawings were seen by Lyman Abbott, editor of the magazine *The Outlook,* who commissioned him to do a whole series dealing with immigrants at Ellis Island. The first of these were published later that year under the title "Americans in the Rough" and brought Stella a number of other commissions as an illustrator. Thus *Survey* magazine (then called *Charities and Commons*) sent him to West Virginia in 1907 to cover the Monongah mine disaster, and the following year to Pittsburgh, where he drew the city, the steel mills, and their workers. At the same time he continued to sketch copiously for his own pleasure, and some of his finest works were the uncommissioned figure studies and landscapes of these years.

The hundreds of drawings that Stella did between 1905 and 1912 fall into several stylistic groups. Two of these were marked by a strong old-master influence. "The forceful penetrating characterization of Mantegna's engravings," he wrote, "and the powerful dramas depicted for eternity by Giotto and Masaccio, so much admired in the mother country, were ever present in front of me, urging me to search for tragic scenes." In addition he appears to have studied the drawings of later men, such as Leonardo, the Carracci, and Domenichino, although he never worked directly in the manner of any

one of them. His earliest predilection was for the analytical, realist aspects of Renaissance art. A series of portrait studies of old men—sometimes only the fragment of a head—are modeled with such minute attention to every wrinkle and blemish in the eroded flesh that they take on a grotesque quality, not unlike Leonardo's caricatural drawings. Several are done in silverpoint with a peculiarly ghostly effect, the image seeming to dissolve into the background, the texture turning to stone instead of flesh *(Ill. 7)*. Later, after Stella's return to Italy about 1909, he transferred his allegiance to the more classical aspects of Renaissance art. The drawings of this second group—musicians *(Ill. 28)*, mothers and children *(Ill. 27)*, and profile heads *(Ill. 22)*—are larger in scale, as well as in actual size, than most of his American studies. The modeling is generalized, the volumes are ample, the emphasis is on linear, flowing contours. In some the serenity of Raphael can be felt, in others the more romantic chiaroscuro of the Caravaggio school, but the result is not as eclectic as it may sound, for the keenness of Stella's own observation informs all this work and gives it, despite his borrowings, a singularly contemporary feeling.

The drawings devoted to Pittsburgh form a third stylistic group. Stella's feelings for the city were ambivalent. On one hand he was struck by its beauty, "beauty lying in the arabesques of form given by the structures of those huge volcano-like steel mills, emerging from the fluctuating waves of smoke and fog with an eloquent mystery." At other times he saw its ugliness and once noted on a scrap of paper: "The snow had fallen and everything was pure and immaculate. It seems to me that God had pity on the poor muddy dark city. . . . I do not know why: there was an air of derision . . . like seeing an old prostitute dressed in white garments for the first communion." He drew the latter scene in *Pittsburgh, Winter (Ill. 19)*, which does indeed transform its subject, though less by snow than by Stella's romantic and impressionist handling. Here, and in a number of other drawings such as *Mill Interior* and *Pittsburgh, Workers' Houses (Ills. 10 and 20)*, the forms are half consumed by the murky atmosphere, emerging with that "eloquent mystery" which he felt. Elsewhere a starker reality prevailed. Two extraordinary works, *Underpass* and *Dark Bedroom (Ills. 18 and 9)*, are somber evocations of industrial drabness, powerful in the simplicity of the drawing and in Stella's daring use of black voids. Most realistic of all are the studies of individual workers, such as *The Puddler* or *Four Miners (Ills. 14 and 17)*, in which he reverted to the analytical precision of his earlier immigrant studies. All of the Pittsburgh drawings are remarkably free from stylistic conventions, traditional or contemporary, and their variety seems a direct reflection of the various moods that his subject inspired in him.

In 1909, possibly early in 1910, Stella returned to Europe for about three years. While his exact movements are not clear, he apparently spent the first year or so in Italy, perhaps visiting Venice and living for some time in Florence, Rome, and in his native Muro Lucano. There is no evidence that he went to Milan or that he encountered either the Italian Futurists or their work during this period. Indeed, the living painter who impressed him most (judging by the long memoir he later wrote) was Antonio Mancini. Stella spent many hours in the latter's studio in Rome and recalled with admiration his "absorbing concern [with] the most exact reproduction of truth. . . . When he exaggerated, for display as he used to say, and would forget to do his duty with respect to truth to nature, he barked out with invective against himself— 'Mancini idiot, Mancini fool, Mancini stinker.'"

But it was the art of the past, rather than that of the present, that Stella sought to emulate in his own work at this time—particularly its technical aspects. In one version of his *Autobiographical Notes* he implies that his interest in Renaissance technique was born while he was still in America, that he had read Cennino Cennini's early treatise on painting methods and had adopted glazing before he came to Europe. There are no existing paintings to substantiate the claim, however, and it seems more likely that his account (if it is by him) in the manuscript *Notes about Joseph Stella* is correct. On his arrival in Italy, he wrote:

> The Venetians at first impressed him very strongly with their wealth and display of rich colors. He read every volume, ancient and modern, dealing with their technique, from which he learned the process of glazing, which consists of placing as a base the body of color in tempera, and after[ward] getting upon the tints in diluted oil color. This method is nowadays not used any more and it is ignored by the majority of artists. The quality that one gets by employing it is a great solidity and a marvelous transparency and depth of color. Here in America, the only painter that has used it effectively, to some extent, is Ryder.

Today few examples of Stella's glazed work are known. Of these the most ambitious is his *Italian Church (Ill. 24),* a painting oddly Ryderesque in its dark tonality and mysteriously looming forms. There are probably others still abroad, for Stella reported that the city of Rome bought one for its municipal collection. Another, which has disappeared, was the portrait of a Venetian architect. According to Stella, a customs inspector, convinced that this was an old master, refused him permission to take it out of Italy until he had proved his authorship by producing the sitter.

Stella's interest in glazing was brief, and he gave it up abruptly.

When in my native town one morning in front of a rosy mountain, I felt unable to realize my vision quickly, without waiting for the preparations required by glazing, I tossed out this method without any stupid regret. I was getting more and more convinced that the true lesson given by the old masters is an ethical one, how to organize the personal capacities in order to be true to his own self, how to derive his credit by his own experience lived at his own time . . . instead of walking back to the past.

Yet throughout his life Stella kept his admiration for the old masters—an attitude, incidentally, quite different from that of the Futurist founders, who proposed relegating them to the dustbin.

PART TWO
TO FUTURISM AND BEYOND

Paris had become the Mecca for any ambitious artist in search of the new verb in art—and in 1911, with great joy, I flew to the Ville Lumière. . . . At my arrival, Fauvism, Cubism and Futurism were in full swing. There was in the air the glamour of a battle. . . . My youth plunged full in it.

I began to work with real frenzy. . . . No more inhibition of any kind for the sake of inanimate sobriety, camouflaged poverty derived by the leavings of the past art, but full adventure into a virgin forest of thrilling visions, heralded by alluring vivid colors, resonant as explosions of joy.

Thus Stella recalled many years later his first contact with the modern movements. Apparently it was not quite like that, for among his papers there is a fragmentary manuscript entitled *Modern Art,* which probably describes more accurately his feelings at the time.

I was called to Paris [he wrote in this] by a friend that at the time I thought was very dear to me. His name was——[illegible]. His nickname was furry on account of his hair brushed back high on his . . . narrow skull. With no talent at all for the graphic arts, he was filling his aesthetic dowry with everything he could find in the immense art ash can in Paris. He was rolling big . . . words: his verbosity was unlimited. It was the time when cubism was dawning. Matisse and the Fauves were at the apogee of their popularity. Cézanne and Renoir . . . Gauguin and Van Gogh had died not long . . . before, and the Fauves were gathering all the spoils that those martyrs had left. . . . Somehow in a little side street in Montparnasse there was a family that had acquired some early work of Matisse and Picasso. The lady of the house was an immense woman carcass austerely dressed in black. Enthroned on a sofa in the middle of the room where the pictures were hanging, with the forceful solemnity of a priestess or Sibylla, she was examining pitilessly all newcomers, assuming a high and distant pose.

Stella's first reaction to the Cubists and the Fauves seems to have been little warmer than Gertrude Stein's reception of him. And indeed the shock must have been great, for he told a *New York Sun* reporter who interviewed him while the experience was still fresh in his mind (May 25, 1913) that the impaot "was so overpowering and dazzling that he was incapacitated for work for nearly six months." It also explains, no doubt, why his own paintings, when he did return to his easel, were far from avant-garde in character. Of the few known today, all are still lifes, the most impressive example being the one in the Alan Silber collection *(Ill. 32)*. In this picture Stella aligns himself with the Post-Impressionists; the high key, the sensitive color harmonies, the vivacious surface and the flat design, which still hints at the illusion of depth, are more akin to the aesthetics of Bonnard than of Picasso or Matisse. Stella had taken a long step from his emulation of the old masters, but he had not gone all the way.

At the same time, his understanding of the more radical movements must have grown rapidly. Eventually he met Matisse and was "enchanted with the intense freshness of his alert color." Once he was introduced to Picasso at the Cirque Medrano and told him he admired his Blue Period paintings, a rather backhanded compliment in view of what Picasso was doing at the time. His closest friend was Modigliani, whose studio in the Impasse Falguière was near Stella's. Often on their walks, "going together through the Boulevard Pasteur, my large frame emphasized by my large American overcoat properly shielded his figure from the inquisitive sight of his ferocious creditors standing at the door of their groceries."

Most important for his own art was Stella's contact with Futurism, then at full tide. The two Futurist manifestos had already been issued (in 1909 and 1910), proclaiming a racing motorcar more beautiful than the *Victory of Samothrace* and that "all subjects previously used must be swept aside in order to express our whirling life of steel, of pride, of fever and of speed." In February, 1912, the five Italian artists who were the founders of the movement, in painting, held their first Paris exhibition at the Bernheim-Jeune Gallery and demonstrated the various ways in which they had built, on the foundations of Cubism, an art of dynamic motion, of force lines, multiple images, and fractured shapes in patterns of speed. Stella knew three of them, according to his *Autobiographical Notes:* Carrà, Boccioni, and Severini. About ten years later he wrote to the first:

We met at the Bernheim Gallery in Paris, at the first Futurist exhibition—and perhaps you will not remember me, as we have not seen each other again. Though from a distance, here in New York (where I have lived for years) I

have always followed with interest and strong liking your lively work of an artist innovator and I have always hoped, for the love that I bear my country of origin, for a show in New York of the bold and recent conquests accomplished by you and your companions to the glory of Italy.

From the tone of the letter, they were scarcely intimate and Stella probably knew the others no better, but he must have studied their work carefully, as events were to prove.

The *New York Sun* article mentioned above reports that from Paris Stella "went back to his mountains" in Italy, but nothing is known of this interlude. He returned to New York late in 1912, possibly early in 1913, had a one-man exhibition at the Italian National Club, and contributed two (perhaps three) pictures to the now famous Armory Show, which first introduced the modern movements to America on a large scale, and which ran in New York from February 17 to March 15, 1913. The dates are important because, according to Stella's testimony in his *Autobiographical Notes,* his own first Futurist canvas, *Battle of Lights, Coney Island (Plate I),* was not started until shortly after the exhibition had closed. The often published story that it hung in the Armory Show is apparently traceable to an error by Katherine Dreier in the catalogue that she compiled of the Société Anonyme collection when it was given to Yale University. Nowhere does Stella himself make such a claim, and the Armory Show catalogue lists only two still lifes by Stella, one of them the painting discussed previously *(Ill. 32),* the other probably a similar example of his Paris work.

The one major modern movement not represented in the Armory Show was Futurism. When Stella embarked on the painting of *Battle of Lights, Coney Island,* therefore, he was forced to rely on his memory of the works he had seen in Paris a year before. He probably did at least one preliminary study in oil *(Ill. 35),* which is not, however, very closely related to the big canvas. Indeed it is not Futurist at all, but in its enlarged pointillism, or divisionism, combined with a vivacious linear design, it is remarkably similar to pre-Futurist canvases by Severini, such as his *Spring in Montmartre* of 1909. It seems almost as if Stella had set himself this task of mastering the Italian artist's earlier style before following him into Futurism. When the moment came, he must have remembered Severini's big canvas *The "Pan Pan" at the Monico,* which hung in the Bernheim-Jeune exhibition but has since been destroyed. Perhaps he had also seen *Dynamic Hieroglyphic of the Bal Tabarin (Ill. 36),* which Severini painted after the exhibition closed but while Stella was still in Europe. *Battle of Lights, Coney Island* bears a quite striking re-

semblance to the latter in a number of ways: in its circular composition, in the weaving together of faceted abstract forms with sinuous ones that sweep through them, in the introduction, here and there, of realistic details, as if the wild motion had stopped just long enough for us to recognize a head, a figure, or an object, in the use of disjointed letters and words, PARK or VALSE, and especially in the whirling carnival atmosphere of the whole. Despite these debts, Stella's painting is quite different from Severini's. The color is deeper and richer, the forms are smaller, more crowded, more active, the design is centrifugal rather than truly circular; it explodes instead of rotating gently. In short, Stella surpassed his model in fulfilling the Futurist program, for his painting is a more intense evocation of motion, glitter, and brassy mechanical sound than is the gay and lyrical canvas of the Italian.

Verbally Stella confirmed his aims with characteristic gusto:

> I built the most intense dynamic arabesque that I could imagine in order to convey in a hectic mood the surging crowd and the revolving machines generating . . . violent, dangerous pleasures. I used the intact purity of the vermilion to accentuate the carnal frenzy of the new bacchanal and all the acidity of the lemon yellow for the dazzling lights storming all around. Arthur B. Davies gave to this painting the place of honor in the exhibition . . . (organized by him) in 1914 at the Montross Gallery.

This was apparently its first showing, after which it was reproduced in color in *Century Magazine* and much discussed by critics and public. From an obscure illustrator, Stella became a conspicuous figure in the American avant-garde, overnight as it were.

He enjoyed the role, met Marcel Duchamp, Picabia, the musician Edgard Varèse, and was soon part of the circle that frequented the Walter Arensbergs'. A little later he was an active member of the Société Anonyme, that brave venture to popularize modern art in America, which was largely supported by the Dreier sisters. It was Dorothea Dreier who purchased *Battle of Lights, Coney Island,* Katherine his first *Brooklyn Bridge (Plate V)*. But in spite of their support, it was not easy for a modernist to live by his art in these years, and there are indications that Stella's brother Antonio was becoming a little restless at the unprofitable direction Stella's painting had taken. "During the . . . great war in 1916," Stella wrote in a manuscript incongruously marked *My sermon about Christ,* "art came at a standstill, hardly any exhibition and hardly any sale. I felt desperate and . . . an absolute need of finding something to do for the gain of my living. When my brother offered me the position of a teacher of the Italian language in a Baptist seminary somewhere in

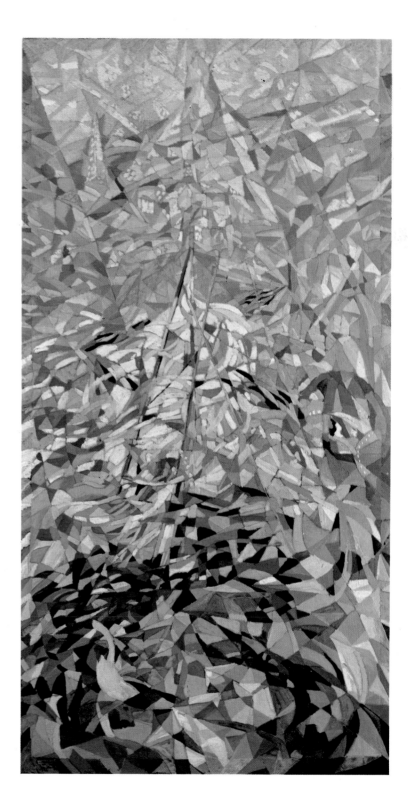

PLATE III. *Spring. Ca.* 1918. Oil. 75 x 40⅛ inches.
Yale University Art Gallery, New Haven;
Collection Société Anonyme.

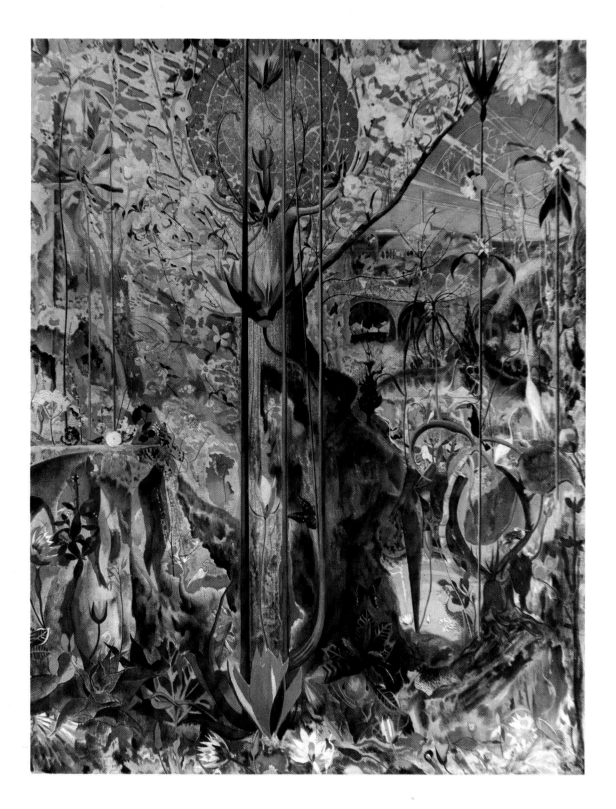

PLATE IV. *Tree of My Life*. 1919. Oil. 83½ x 75½ inches.
Collection of the Iowa State Education Association, Des Moines, Iowa.

Williamsburg, Brooklyn, although the remuneration was scanty . . . I accepted with joy." There he taught mornings and had his afternoons free for painting, an arrangement that gave him the independence he needed, because he would not have to submit his work "to the judgment or approval of anyone, my brother included."

At some time between 1914 and 1918 (he himself gave the later date), Stella painted his second major Futurist picture, *Spring (Plate III)*. At first sight it appears to be completely abstract, and it is certainly more so than *Battle of Lights, Coney Island (Plate I)*, but its genesis can be traced from a quite naturalistic landscape in the Harry L. Koenigsberg collection through a more abstract pastel to the large oil, which—it then appears—preserves certain elements of the original landscape, such as the triangular mountain rising to a peak at the top of the canvas. Furthermore, the pennant-like triangles, of which the picture is almost entirely composed, are tilted in the lower areas to suggest the retreating depth of the landscape at the same time that they function as a flat pattern. This use of active, pointed shapes to define and animate space seems also to have been borrowed from Severini, who employed it in his 1910 painting *The Boulevard*. But again Stella has gone beyond his source in creating a more intense motion. His pennants flutter, wave, move sinuously in and out, whereas Severini's are geometrical and static, defining the planes of the picture and creating only a limited movement by their broken pattern of gay colors.

In a series of lesser works, mostly pastels and drawings, Stella experimented with even more abstract means. In some of these, such as *Abstraction* in the Halpert collection *(Ill. 34)*, he worked with geometrical, intersecting planes. In others, such as *Composition, Mardi Gras (Ill. 42)*, he used irregular circles and radiating lines, rather in the manner of Arthur Dove. In the majority, however, he returned to the predominantly linear patterns of *Battle of Lights, Coney Island* and created a variety of undulating, arabesque-filled designs, like those in *Sunlight and Water (Ill. 40)*, *Abstraction, Garden (Ill. 37)*, and the *Abstraction* owned by the Woodward Foundation *(Ill. 38)*. A lost work, *Mardi Gras* (reproduced in *The Little Review*, 1922), is actually a purely abstract variation on the composition of *Battle of Lights, Coney Island*, done apparently in pencil a few years after the oil. The date is difficult to decipher in the reproduction, but might be 1918. Of the other works above, only *Sunlight and Water* can be dated securely (in 1914). It is likely that the rest were done between these two years, but there is no way of establishing an exact sequence.

In his other oils of the same period, Stella tended to combine the broken

planes of *Spring* with the linear arabesques of *Battle of Lights, Coney Island* in about equal measure, at the same time moving gradually away from abstraction by introducing more and more recognizable elements. Another version of *Battle of Lights (Ill. 43),* almost certainly done after it, is more legibly constructed in terms of space and the relation of objects, but sacrifices some of the motion and excitement in the original. In *Coney Island* and *Der Rosenkavalier (Plate II and Ill. 33),* the effect begins to be even a little decorative; the planes move in a Futurist way, but motion seems strangely divorced from subject, creating arbitrary patterns like those of a kaleidoscope. In *The Gas Tank (Ill. 47),* which is dated 1918, the treatment is entirely realistic, except for a few vestigial flourishes of arabesques, which give the somber industrial scene a strangely mardi gras spirit.

At the same time that Stella was playing variations on his carnival themes, the idea of painting a huge canvas of Brooklyn Bridge, as a symbol of American civilization, grew on him. "For years I had been waiting for the joy of being capable to leap up to this subject," he wrote in *Transition* (June, 1929), "for BROOKLYN BRIDGE had become an ever growing obsession ever since I had come to America." He started his picture in 1918 (according to his *Autobiographical Notes*), probably finished it the following year, and first exhibited it at the Bourgeois Galleries in 1920.

Stylistically, Stella's *Brooklyn Bridge (Plate V)* marks a sharp break with Futurism. About all that it has in common with his previous work is the semi-abstract organization in which fragments of recognizable objects are arbitrarily arranged. But the motion is stilled, the arabesques and the waving pennants banished. Instead, the picture is constructed symmetrically with fixed lines and masses and with a pictorial logic as strict as that of the bridge itself, though greatly different. Having created this paradigm of engineering precision, Stella then deliberately destroyed it by his romantic use of darkness and light, of night voids and shimmering reflections. Here is the reality of the bridge, his picture implies, and here its mystery, surpassing the miracle of its steel and stone existence. His own description makes clear the romantic spirit in which it was conceived.

> To realize this towering imperative vision in all its integral possibilities [he wrote] I lived days of anxiety, torture, and delight alike, trembling all over with emotion as those railing[s] in the midst of the bridge vibrating at the continuous passage of the trains. I appealed for help to the soaring verse of Walt Whitman and to the fiery Poe's plasticity. Upon the swarming darkness of the night, I rung all the bells of alarm with the blaze of electricity scattered in lightnings down the oblique cables, the dynamic pillars of my composition, and to render

more pungent the mystery of the metallic apparition, through the green and red glare of the signals I excavated here and there caves as subterranean passages to infernal recesses.

Stella had hardly finished *Brooklyn Bridge* when "in 1920 I gathered all my strength to assault . . . the theme that for years had become an obsession: THE VOICE OF THE CITY OF NEW YORK INTERPRETED." The five huge canvases *(Ills. 66–69 and Plate VIII)* that constitute Stella's most ambitious work, in many ways his masterpiece, were finished about two years later, for they were exhibited on January 10, 1923, in the galleries of the Société Anonyme. In form they are based on the traditional Renaissance polyptych: a taller central panel, *The Skyscrapers (Plate VIII),* is flanked by two versions of *The White Way (Ills. 67 and 68),* the outer wings being *The Port (Ill. 66)* at the left and *The Bridge (Ill. 69)* at the right. Across the base runs a painted predella of the subterranean aspects of the city. But the conception and iconography are best described by Stella himself.

For years I was dreaming of this tremendous subject, and many times I feared that my idea was impossible to be realized in painting. The prism was composed of so many facets, and above all what to begin with was the most difficult problem to solve. . . .

Continually I was wandering through the immense metropolis, especially at night, in search of the most salient spectacles to derive from the essentials truly representative of her physiognomy. And after a long period of obstinate waiting, while I was at the Battery, all of a sudden flashed in front of me the skyscrapers, the port, the bridge, with the tubes and the subways. I got hold of five big canvases to be clasped in a long rectangular one. I selected this most elementary geometrical form as the most appropriate frame for the simultaneous action of these mechanical essentials chosen.

The vertical line dominates because everything arises and ascends with exasperated impetus. . . .

I used the skyscrapers, the port, the bridge and the white ways as the five movements of a big symphony—a symphony free in her vast resonances, but firm, mathematically precise in her development, the abstract opportunely inserted to realism, highly spiritual and crudely materialistic alike.

The depth of night tempers and renders mysterious the geometrical severity. . . .

The skyscrapers . . . dominate the central canvas, purposely made the highest to break the rectangular monotony, and induced by electricity, blazing at their base with the outburst of two wings ready for flight, embark in adventurous sailing, guided by the luminous edge of the Flatiron Building acting in the middle as the opportune prow.

The bridge arises imperturbable with the dark inexorable frame among the delirium raging all around of the temerarious heights of the skyscrapers and emerges victorious with the majestic sovereignty sealed on his arches upon the subjugated fluvial abyss roaring below with the moanings of appeal of the tugboats.

In the port the horizontal traverses the emerald of the water, obliquely intersected here and there, and upon the blue-green of the whole, funnels of factories and ships ring the bells of a new religion.

Pure vermilion is lighted up at the vortex of a pyramid of black cords—hanging like the ropes of a scaffold—as the burning offer of human labor, while telegraphic wires rush to bind distances in a harmonic whole of vibrating love.

The flux of the metropolitan life continually flows, as the blood in the arteries, through the subways and the tubes used for the predella of my composition, and from arcs and ovals darts the stained glass fulgency of a cathedral.

Certain Futurist devices persist in *New York Interpreted,* but they have ceased to function in a truly Futurist way. The repeated **V**'s at the top and bottom of the central panel are plainly rays of light, not force lines, as in Russolo's work. The **S**-shaped arabesques in one of the *White Ways (Ill. 67)* may recall Russolo's symbol of swelling sound in *Music* or Stella's own arabesques in *Battle of Lights, Coney Island (Plate I),* but here they have become structural elements rather than indications of movement. The most Futurist of the five panels is *The Port (Ill. 66),* with its thrusting horizontal forms, and certainly motion is implicit in the bridge's sweeping cables and the endlessly repeated verticals of the three central panels, but this all seems incidental to Stella's main purpose.

This, it is clear, was to capture the total impact of New York on the senses— that is, the impact of the city's visual and auditory aspects rather than its human conditions. No wonder the task seemed formidable, for its aspects were many: the soaring buildings, the network of communications, the dazzle of lights, the modernity, the noise, the hurry, the endless coming and going. Speed and motion were only a part of this complex, however, and Stella relegated them to a minor role. His great accomplishment, and the true originality of his work, lies in his creation of an immensely complex structure to match, in pictorial terms, the complexity of his theme. And if he has not succeeded in imbuing his vision with quite the sense of mystery and personal response that he achieved in *Brooklyn Bridge (Plate V),* if he has tended to emphasize the garishness and the engineering miracles more than his own romantic perceptions, he can scarcely be blamed. The panoramic sweep of his concept, the sheer variety of his subject, imposed a certain impersonality on its treat-

ment. The wonder is that he achieved in so vast, involved, and programmatic a canvas a design of such sustained vitality.

New York Interpreted was soon recognized as Stella's masterpiece and brought him considerable fame, although the work itself was not purchased (by The Newark Museum) until nearly fifteen years after it was painted. It was widely reproduced, however, and Henry McBride remarked in *The Dial* (April, 1923), "So far more people have asked me what I thought of Joseph Stella's new work at the Société Anonyme than have inquired into any other event of the season." There is also strong evidence (assembled by Irma Jaffe in *American Art Journal,* Fall, 1969) that it had a crucial influence on Hart Crane's poem *The Bridge,* both in its symbolism and in its multipartite organization.

Never again was Stella to attempt so ambitious a painting, but at intervals through the rest of his life he returned to the style and subject of *New York Interpreted,* particularly to the theme of skyscrapers seen through the cables and arches of the Brooklyn Bridge. In his *American Landscape* of 1929 *(Ill. 86),* he varied his earlier treatment with an asymmetrical composition, the cables becoming strong diagonal lines against the verticality of the background. Not only is it less hieratic in design; it is also more loosely painted, the forms softened by atmospheric effects. As a result it has some of the mysteriousness of his first *Brooklyn Bridge (Plate V),* although the mood is more relaxed and less intensely romantic. On the other hand, a still later version, of 1939, *Brooklyn Bridge: Variation on an Old Theme (Ill. 94),* follows in every major respect the design of the *The Bridge (Ill. 69)* in *New York Interpreted.* The principal difference, aside from the rather odd little vignette of the city in the predella, is the treatment of the vista seen through the arches, which is flatter, more schematic, and more symmetrical. Something in Stella loved symmetry, perhaps because of the symbolic effect it created, and here he has used it, together with the more abstract design, to create a kind of altar, or devotional object. The city remained enthroned in his heart to the last.

PART THREE
INNOVATIONS AND EXPERIMENTS

"The first need of the artist is absolute freedom," Stella wrote in a manuscript marked *Jottings,* which can be dated about 1919, "freedom from schools, from critics, advisors and the so-called friends. . . . The audience should not exist while the work of art is done. Birds sing to pour out their joy of living." In a speech before a group of artists (recorded in *Broom,* December, 1921), he was more specific: "If Cubism has declared the independence of Painting, by suppressing representation . . . every declaration of Independence carries somewhat a declaration of a new slavery." Stella's own independence of both academic and modernist standards was uncompromising—to his gain and to his loss—and the same decade of 1913–23 that produced his Futurist-related works also saw him moving in a variety of other directions.

The industrial scene, which had fired Stella's imagination in 1908, continued to fascinate him with the strength and beauty of its utilitarian forms. In 1916, *Survey* sent him back to Pittsburgh to illustrate an article, and in 1918, it commissioned him to do a series of drawings on the war effort, the subjects assigned being shipbuilders, garment workers, Bethlehem, and an airplane factory. Many of the drawings that resulted were sketchy and impressionist in style, and a few related works, such as the gouache *Steel Mill (Ill. 55)* and the pastel *Old Brooklyn Houses (Ill. 41),* are also rather casual in manner. But when Stella's interest was more deeply involved, he drew with the same exactitude and the same powerful massing of darks and lights as he had in the best of his earlier studies. *Factory Landscape, Pittsburgh,* and *Night Fires* are simultaneously realistic and romantic evocations of the industrial scene.

About 1920, Stella began to treat these architectural and industrial subjects in a somewhat different manner. In a watercolor, *Building Forms (Ill. 57),* dated 1915 but probably done considerably later, he simplified the structure of

his subject, suppressed the details, and modeled the large masses with sharp clarity; the result was a semi-abstract design that yet remained faithful to visual reality. During the same period he applied this method to several oils of factories—one in The Art Institute of Chicago, one in The Museum of Modern Art *(Ill. 63)*—and to another, *Smoke Stacks (Ill. 64)*. In these, the design is nearly geometrical. The cylindrical chimneys and tanks form a varied progression of vertical masses, sometimes seen in full volume, sometimes as flat silhouettes. They are crossed at right angles by the pipes, rails, and conduits, while an occasional diagonal is introduced in a strut or a chute. Even the smoke has become a simplified mass in the semi-abstract orchestration of mechanical forms. In a gayer vein, a *Telegraph Pole (Ill. 59),* its wires radiating in multiple directions, cuts across the complex outline of distant roofs.

These pictures of about 1920 may have played some part in establishing the attitude and formal vocabulary of the so-called Precisionists in American art. Charles Demuth, an early founder of the movement, was experimenting with a semi-abstract treatment of building forms by 1917, but his paintings then were more Cubist in manner, the shapes more arbitrarily cut up and rearranged. It was not until *End of the Parade* in 1920 that Demuth discovered the possibilities of the industrial scene and treated it with a certain respect for its inherent engineering logic. Charles Sheeler's *Church Street El,* his first truly Precisionist painting, was also done in 1920; Niles Spencer and the others came later. That they owed much to Stella is doubtful, for he did not long pursue this direction, but he can lay claim to have been among the first to create that peculiarly American hybridization of realism and abstraction, derived from the equation of functionalism and beauty, which was at the heart of the Precisionist movement.

Stella's love of the city and his interest in industrial forms were only two facets of his restless personality. No one direction in art ever absorbed him completely. Probably he saw himself in terms of the Renaissance ideal of the universal man; in any case, he quite consciously cultivated variety. "In the meantime," he wrote (of the period that produced *Brooklyn Bridge* and *New York Interpreted*), "I deepened my researches regarding the human figure and all the natural forms (animals and plants alike) to keep alert my interest." Many years later, August Mosca recalled: "He loved fruit and flowers. . . . He very carefully selected his fruit for size and peculiarity of color shapes, exclaiming constantly on their beauty."

Stella's treatment of the human figure at this time differed considerably from that in his earlier drawings. A series of portrait heads—of Marcel Duchamp, Edgard Varèse, and at least two of his fellow artist Louis Eilshemius

(Ills. 61 and 62)—show the old realism, but tempered by a new delicacy that was not solely that inherent in the medium. It was a more selective realism, achieving character with great economy of means, sometimes only a few lines, and eschewing the nearly clinical analysis of flesh in the early heads. A decorative aim is apparent, both in the placing of the figure on the paper and in the emphasis on contours. The latter quality is even more marked in some later drawings, such as *Sleeping Woman (Ill. 90)*.

When Stella turned to botanical subjects—and the term seems justified by the extreme precision with which every leaf, stem, and blossom was rendered—he heightened both the delicacy and the decorative handling. A silverpoint of *Palm Fronds (Ill. 60)* is not only exact in every detail, it is also a composition of radiating lines, made nearly abstract by the closeness of the view. *Lupine (Ill. 49)*, on the other hand, looks like the design on some object of chinoiserie, or the wonderfully decorative illustration in an early French botanical treatise. Even the delicate tracery of the roots is revealed and plays its part in the linear pattern. In a still different vein, *Tree Trunk (Ill. 51)* and *Pomegranate (Plate VI)* are magnified studies of color and texture. Stella must have selected them for their very oddity, which he has emphasized by the enlargement of detail and the insistent modeling. They have a tactile immediacy and a strangeness of shape and color that inspires both fascination and repulsion. A much later *Tropical Bird (Ill. 95)* has somewhat the same exotic quality.

It was only a step further to outright fantasy, and Stella occasionally took it. His crayon *Sunflower (Ill. 52)* might conceivably have grown a stem as convoluted as the one he has drawn, but it seems more likely that the artist bent nature to his own ends; in any case, the impression of a giant hooded cobra rearing to strike is inescapable. He may well have found a zucchini in the semblance of a swan *(Ill. 53)*, but he has dressed it in the trappings of his own romantic imagination by setting it on a shadowy lake in a dreamlike landscape. This is perhaps a little too obvious—almost a visual pun. Stella was generally subtler, depending on the variety and unexpectedness of nature itself for his material, and revealing its richness and strangeness by more pictorial means.

In Stella's total work, his collages stand out today as perhaps his greatest innovation. When he began, about 1920, to mount these ragged scraps of debris in irregular designs that are so mysteriously evocative, nothing at all like them had been done on either side of the Atlantic. Most of them are a world removed, except in technique, from Cubist collage; and Schwitters's *Merzbilder,* which were not much like them anyway, were doubtless unknown to Stella at this time. Stella's collages even seem remarkably unrelated to any-

thing else in his own work, until one compares them with some of the botanical studies, such as *Tree Trunk (Ill. 51)*. Then it becomes apparent that the eye that lost itself in the minutiae of natural forms and textures was equally fascinated by the accidental ones of civilization. "Walking along the street," Mosca recalled, "he would . . . pick up torn, discolored pieces of paper which would be pasted on color backgrounds that constituted his 'Naturelles'; interesting patterns made by footprints, auto tire prints, plain dirt and dirty water." Sometimes nature, too, provided his materials—a scrap of bark or a dead leaf *(Ill. 73)*, but for the most part his source of supply was the gutter.

In a few of these collages remote echoes of Cubism can be sensed. *The Bookman, Gray and Orange, Number 14 (Ills. 70, 74, and 76)* have at least some rectilinear elements and the suggestion of formal design, though broken by persistent irregularities. More typical, however, are those focused on a single free form, a torn, eroded, predominantly accidental shape that, by its isolation and the very fact of being mounted and framed like a precious object, acquires a mysterious significance. *Graph, Number 21 (Plate X),* and many others have these looming central images that look simultaneously like a face, a rock, the map of a lost island, or whatever else the imagination may imbue them with. At the same time, one is persistently aware of their humble origins in city debris, and the precarious balance between what they are and what they evoke is an important part of their character.

Sometimes Stella's collages are associated with a specific subject. One of these, reproduced in *The Little Review* in 1922, now lost, was a narrow tower assembled from four ragged strips of paper and entitled *Study for Skyscraper;* in the lowest fragment the word "PAIN" is perforated. More often he was content to manipulate color, form, and texture for their own sake. In this he maintained an equally precarious balance between accident and control, even (one suspects) applying water, grime, or his own footsteps to achieve effects he sought, just as he occasionally used paint in irregular stains that are almost indistinguishable from the haphazard patterns of wear. It is here that he stands as a forerunner to the Abstract Expressionists, who have held a similar dialogue between conscious creation and the ready acceptance of the dictates of chance and medium.

The deliberate courting of chance as a working procedure has today, of course, surpassed anything that Stella did or contemplated. The accidentally spilled paint that is reputed to have determined the blue poles in Jackson Pollock's painting of that title, like the stains on the back of a canvas that led James Brooks into a new phase in his art, is an event that Stella could scarcely have found useful. His attitude toward the odds and ends he collected for his

collages was much less complicated, for he was not engaged in any deliberate effort to suspend his aesthetic impulses. Like Leonardo he may have seen in these accidents of wear and use the suggestion of landscapes and battles; more likely he simply found them beautiful. His virtue is that he discovered beauty in an area where it had lain unsuspected, and that through collage he found the means to embody it in a poetic expression both mysterious and lyrical. In the process he transformed the nature of collage itself, greatly enlarging its traditional boundaries.

PART FOUR
SYMBOL AND FANTASY

On July 22, 1921, Louis Eilshemius wrote a poem to his good friend Joseph Stella:

> There lives within our city
> A great Italian, who a painter is
> He would to hear again the ditty
> The peasants sing, far far in Italy
> Homesickness and slight living cares
> Eat up his heart, while painting here
> Works far too great for our own men to feel.

It is not immortal verse, but Eilshemius put his finger on a trait in Stella's character that was to exercise an increasingly important (and not always salutary) influence on his art during the last third of his life. This was his nostalgia for Italy, an emotion bound up with shining visions of his youth and with reverence for the great artistic traditions of the Renaissance. It led Stella to do a long series of symbolic canvases and eventually into attempts to translate Renaissance art into modern terms.

At first, it was solely the recollections of childhood that he sought to express. Two pastels of 1918—*Song of the Nightingale* and *A Child's Prayer (Ill. 48)*— are obviously rooted in memories of his youth in Muro Lucano. In these, the symbols themselves are abstract: The rising and falling notes of the song are transposed into a linear pattern, while the prayer ascends in rays and billows of light. Yet neither is truly abstract, for the mountainous landscape of the artist's birthplace is plainly the setting for the first, its Gothic architecture for the second. These settings, however, are far from naturalistic. The mountain, shadowy and unreal, has been schematized into a perfect half-sphere; the

arches of the church have been fragmented and blended into the symbolic design. Each picture is a dreamlike expression of a yearning remote in time and place from its object.

As Stella worked on his big Futurist canvases, celebrating everything that was modern and clangorous in twentieth-century life, such contradictory visions of a timeless and innocent past assailed him with increasing frequency and power. About 1919, just as he was finishing his first *Brooklyn Bridge (Plate V)*, one of them became so insistent that he turned aside from the city long enough to paint it before going on to *New York Interpreted (Ills. 66–69 and Plate VIII)*. The inception of *Tree of My Life (Plate IV)* is described at the end of Stella's article in *Transition*.

> The work [on *Brooklyn Bridge*] proceeded rapid and intense with no effort.
> At the end, brusquely, a new light broke over me; metamorphosing aspects and visions of things. Unexpectedly, from the sudden unfolding of the blue distances of my youth in Italy, a great clarity announced PEACE—proclaimed the luminous dawn of A NEW ERA.
> Upon the recomposed calm of my soul a radiant promise quivered and a vision —indistinct but familiar—began to appear. The clarity became more and more intense, turning into rose. The vision spread all the largeness of Her wings, and with the velocity of the first rays of the arising Sun, rushed toward me as a rainbow of trembling smiles of resurrected friendship.
> And one clear morning of April I found myself in the midst of joyous singing and delicious scent—the singing and the scent of birds and flowers ready to celebrate the baptism of my new art, the birds and the flowers already enjewelling the tender foliage of the new-born tree of my hopes—"The Tree of My Life."

Two thoughts are imbedded in the rhetoric: the source of the vision in "the blue distances of my youth in Italy," and the realization that to paint it would require a "new art." The latter turned out to be a clutter of borrowings from the Renaissance primitives: the little fragments of landscape, the aureole at the top, the profusion of flowers and foliage painted in loving detail, the bright, sweet colors. Plainly, Stella hoped to recapture the joy and the pictorial innocence of early masters like Fra Angelico and Filippo Lippi, and, just as plainly, he failed. Yet the picture itself cannot be called a failure, in spite of its eclecticism and sentimentality. It is saved by its very immodesty, by the complete lack of restraint with which Stella piled up his borrowed treasures in a profusion that bewilders the eye. Everything in this melange is seen a little larger than life, particularly the flowers, which are gigantic. An oddness of proportion and a fantasy of shape transform the realistic detail into some-

thing close to Surrealism, although that movement had not yet been born. Echoes of Stella's earlier symbolic pictures reverberate strangely through the composition; the cluster of vertical trunks or stems in the center is reminiscent of *Song of the Nightingale;* the canopied form at the right suggests the Gothic arches of *A Child's Prayer (Ill. 48).* In the end it is the picture's sheer extravagance, its irrepressible romantic vitality, that triumphs. Its title is only partially correct; it is not the life-tree of the whole Stella, but it is the pure expression of one side of his nature—a side that, for better or worse, was to gain the ascendancy during the last twenty-five years of his life.

In 1922, Stella's homesickness drew him back to Italy, where he immersed himself in the art of antiquity and the Renaissance and painted some of the most eclectic pictures of his career.

> I went to Naples and I was so happy to paint there THE VIRGIN [now in The Brooklyn Museum] with the same mystical rapture that seized me in my early childhood after reading in Vasari's book about the holy marvels sung by Lippi and THE DIVINE FRA ANGELICO. The Hellenic miracles of the Neapolitan Museum . . . kept me spellbound. I was in heavenly ecstasy visiting Pompeii, Herculaneum, Paestum. And when in Capri I was shrouded by a miraculous blue, flooding both sky and sea, all of a sudden sprung in front of me the myth of THE BIRTH OF VENUS [now owned by the Iowa State Education Association in Des Moines]. . . .
>
> I was in a state of grace, painting from morning to night, living a life of complete bliss.

Stella's return to America in 1923 seems to have jolted him, at least temporarily, out of his emulation of the past. In the next few years he painted a few symbolic canvases that take a certain hold on the imagination by their strangeness. He had hardly landed when "I was struck by the conquests obtained in every domain by the American Woman. My admiration for her became keener, and I painted, in her homage, a canvas entitled AMAZON (the Amazon of our time)." To be sure the picture *(Ill. 78)* is based on the traditional Renaissance profile portrait (a convention that Stella used over and over), but in this case the head is so brassily painted, so oddly placed, so huge in proportion to the setting, and so incongruously silhouetted against Vesuvius and the Bay of Naples that the effect is purely fantastic. Another painting of about the same time, *The Swan (Ill. 77),* seems also to have symbolic overtones, although its original title and its iconography are unknown. In any case, the gigantic bird fills the upper half of the circular canvas like a heraldic image, while behind it the sky is arbitrarily divided into night and day. The picture has the peculiar optical effect of expanding, perhaps due to the con-

centric design, until the eye is lost in the light-filled space of Stella's imagination.

In 1926, Stella returned to Europe, where he lived continuously for the next eight years, except for a brief trip home in 1928. Much of the time he was in Paris, although he also made several visits to Italy. More important, for his art, was an unknown number of voyages to North Africa that he took during these years. From them came that series of extraordinary jungle fantasies, which were perhaps the finest achievement of his later career. By the mid-1930's, he seems to have been well known for them, for Holger Cahill, head of the WPA Federal Art Project (on which Stella was briefly enrolled), wrote him in July, 1937, "When we were thinking of the projects for Puerto Rico and the Virgin Islands . . . now in abeyance . . . your name occurred to me at once."

Most of Stella's North African subjects were painted in the brief period of 1929–30, but his first work in this vein, the large *Tropical Sonata (Plate VII),* must have been done before 1922 (it was reproduced in *The Little Review* in that year). As in so many of Stella's major works, the composition is basically symmetrical and dominated by a strong vertical axis, here the palm tree. This in itself tends to dispel any illusion of observed reality, turning the picture into a kind of schematic symbol of all palm trees—a symbol not without phallic undertones. The symbolic feeling is heightened by the abstract patterning of the foliage and the lack of any specific background that might suggest a specific location. Beyond these rather obvious devices, there is a quality in the forms themselves, in the writhing, probing foliage moving in and out of mysterious depths, which distills a powerful, even repellent image of growth. At the same time, the balanced intervals between light and dark, form and shadow, suggest the musical analogy implied in the title, although the painting seems less a sonata than a dark, Sibelius-like symphony to the forces of the jungle.

Stella's major tropical oils of 1929–30 are, on the other hand, even more schematic than *Tropical Sonata. The Red Flower (Plate IX)* is built around a blossom of gigantic proportions, which bisects the canvas like a weird totem. On either side of it, two birds stand in heraldic postures, as if frozen in some rite of worship. Behind it a tree divides in a perfect Y, and the spaces on either side are filled with patterns of foliage, effectively blocking off any suggestion of depth. The picture has become a flat pattern of tropical motifs and is only saved from decoration by the richness of the painting, the strangeness of the proportions, and the way in which the profusion of forms looms out of the dark background. In other oils such as *Forest Cathedral (Ill. 87), Green*

Apple (Ill. 89), and *Black Swan (Ill. 80)* he moved still further toward a symbolic and decorative treatment. Of these, the strangest is *Green Apple*— more likely a tropical fruit, since the original title is lost and the author's botanical lore unreliable. Here, in any case, a completely flat frieze of foliage frames the insistently modeled sphere, and, as if this odd contrast between decorative and realistic treatment were not enough, a vast panorama of empty space stretches to a distant horizon behind. The effect is strongly surrealist, reminding one of Magritte's isolated objects floating in illimitable vistas, but whether Stella had seen the work of the Surrealists in Paris at this time is unknown.

After the spate of tropical pictures of 1929–30, Stella seems to have abandoned the subject for some eight years, perhaps because New York in the Depression provided neither the material nor the mood for such fantasies. Only a strange stroke of fate brought him back to the tropics, late in 1937, and produced a final flowering of this aspect of his art. The cause was bound up with one of the persistent mysteries in Stella's personal life, his marriage many years before (the date is still unknown but was sometime between 1902 and 1916) to a woman whom his family never met, whose name they did not know, and from whom he lived in estrangement for most of their married life. She was said to have been born in Barbados, however, and recent research there, generously undertaken at the author's request by Mrs. H. W. Nice, has uncovered at least the bare outline of her story. She was born Mary Geraldine Walter French of Speightstown, on January 29, 1882. Early in the present century she came with a sister, or sisters, and a younger brother to the United States, where they settled in Philadelphia. How she met and married Stella, why they separated, or what brought them briefly together again may never be known, but on the last point there is a persistent story that Stella took her back to her birthplace to die. This is at least partially confirmed, because she stayed on the island when he left in mid-1938, was then suffering from diabetes, and did die in the Barbados General Hospital on November 29, 1939.

When Stella left for Barbados in December, 1937, he plainly intended to work, for a shopping list among his papers indicates that he took with him: "Silverpoint paper . . . paper for pastels (velour), paper for charcoal, gray and black paper, pastels . . . oil paint . . . canvas of various dimensions, large and small stretchers." The island apparently lived up to his expectations; in a one-page manuscript entitled *Barbados,* he later wrote:

For the daring adventurous painter, Barbados is a magic island. Unheralded, the enchantment of its beauty dazzles with all the golden vehemence of an unex-

pected rising of a new Sun. The intense chromatic wealth forever singing all around . . . is the proper ornament for the imposing temple elevated by the majestic columns of trees darting from a sculpted coral pedestal. And frequently, as a climax to this everlasting celebration of the joy of living, rainbows unfold all the glory of celestial hues unsealed from Paradise, to clasp in a divine union the terse blue and the vivid emerald gleaming from the sky and the sea.

Song of Barbados (Ill. 92), the most ambitious of his paintings done on the island, is a synthesis of these impressions. In it, he has arbitrarily combined the sky, the sea, the columnar trees, and even, at the bottom, the coral structure of the earth. The design is familiar—central axis, symmetrical pattern— but the treatment and the feeling differ somewhat from the earlier tropical oils. The modeling is harder, the volumes more sculptural. Much of the mystery has disappeared, replaced by a simpler pleasure in the wealth of fantastic forms. The same characteristics can be found in other paintings that Stella did after he left the island, such as *Full Moon (Barbados)* of 1940 *(Ill. 93)*. Here the composition is almost a replica of that of *The Red Flower (Plate IX)*, but the dark profusion of the latter has yielded to a less complicated, more monumental design. Perhaps these differences sprang in part from actual physical differences between Barbados and North Africa. It seems more likely that they are reflections of a change in Stella's own attitude, as if he now saw the tropics with a newly lyrical eye and was intent on expressing not their romantically menacing aspect but their delights of color and form. Like the rainbow, his tropical paintings became, at the end, his personal "everlasting celebration of the joy of living."

PART FIVE
THE LATE YEARS

Every major direction in Stella's art had made its appearance by 1922, and nearly all his best paintings had been done by then. Yet the last twenty-two years of his active career were far from sterile. In addition to the tropical fantasies and the symbolic pictures, he turned out a number of portraits, landscapes, and still lifes that are of more than passing interest. One of his favorite subjects was himself, seen invariably in a heroic mold that verges on the theatrical. Among the many revealing self-portraits of his middle age, that in the Herbert A. Goldstone collection *(Ill. 82)* is perhaps the most unusual, not only for its sense of character and handsome design but also for the unconventional technique of wax and watercolor in which it is done. The effect produced in the background is very much like the eroded surfaces of his collages and forms a strange contrast to the smooth, classically painted features with their bold outlines.

Stella's landscapes of the 1920's were painted in a variety of styles and moods. *Muro Lucano (Ill. 81)* is almost abstract, though not at all in the manner of his Futurist abstractions. The buildings have been reduced to geometrical masses, their edges blurred and softened by atmosphere, and the whole mountain glows like a many-faceted jewel, unreal and hallucinatory. In the very large pastel *Nocturne (Ill. 83)*, the forms have become even more veiled and indistinct, to the point where it is difficult to make out what they are as they retreat mysteriously into darkness. *Cypress Tree (Ill. 79)*, on the other hand, is stark, sharp-edged, and explicit. The only characteristic that it shares with the others is the radical simplification of objects and the semi-abstract design. But in its deliberate hardness and rectilinear pattern it seems more a throwback to Stella's Precisionist work of a decade earlier.

It was in still life, however, that Stella did his most consistently creative

painting during the latter part of his life, again excepting the tropical fantasies. "If you climb the stoop and knock on his door," Charmion von Wiegand wrote in an unpublished memoir,

> you are admitted to an old Victorian parlor piled high with paintings, books, mementos, and stacked with portfolios and statues. . . . Flower studies of all kinds litter the floor and turn it into a growing garden. The old-fashioned fireplace with its huge gilt mirror groans under a weight of countless knickknacks, curling green gourds, African masks, French puppets, a plaster madonna, a copy of Mantegna's *Dead Christ,* a bit of Indian embroidery. They are not useless ornaments; they have all posed for Stella and you will encounter them in his watercolors of still life.

She might have added a branch of white coral, probably from Barbados, which he used again and again.

Stylistically, Stella's still lifes are quite different from his other work. In their free distortions and arbitrary, sometimes strident color, they mark his closest approach to Expressionism. Often they are nearly abstract in their patterning, as in the *Still Life* owned by the Whitney Museum *(Ill. 84),* which has something of the flat, asymmetrical design of an Arthur Dove. The gouache *Sunflower (Ill. 85)* is even more Dove-like, for the ragged, concentric circles of the flower's head seem to take on symbolic significance, suggesting an expanding, strangely warped sun. Quite violent contrasts of texture and form add to the pictorial drama of these works, the ragged silhouette of a yellow melon erupting fantastically between the stolid spheres of a lamp and a bowl *(Ill. 88),* for instance.

At the very end of his life Stella was still painting some of his finest still lifes. A large one in the Leonard M. Weinstock collection *(Ill. 96)* reminds one of the primitive expressionism of Marsden Hartley; the heavy forms have an ungainly strength, the color is deep and resonant. Quite different in character is the delicate little *Still Life with Small Sculpture* of the same year, 1944 *(Ill. 97),* in which Stella became fascinated with the reflections in a polished tabletop and used them to create a faceted, almost Cubist design. Again the color—here high-keyed and bright—is a major element, and it is not surprising to find among Stella's papers a random note on which he had scribbled in Italian, probably many years earlier: "I use color, whether on canvas or cardboard, as incentive, or an awakener of my painter's faculties. . . . [It] stimulates, provokes, teases my artistic temperament like the vermilion silk agitated by the matador before the inflamed eyes of the bull." Stella's color

sense, in fact, was far from infallible, as some of the candy-box hues of his symbolic and religious paintings testify. But in the majority of his still lifes, for some inexplicable reason, color plays a consistently strong and satisfying role.

In spite of a certain continuing success, and the esteem of a small circle of artist friends, one cannot escape the feeling that Stella's last years were an anticlimax. The fame that he had tasted so briefly but headily in the early part of the century had eluded him, and with it the hope of financial security. A number of ambitious plans went sadly awry. With August Mosca he dreamed of recouping his fortunes by founding the Joseph Stella School of Art, but some of the items on Mosca's agenda reveal its visionary nature: "Lease studio, as large as possible for the least cost. . . . Mr. Stella to give us more specific details on how Chase conducted his classes for foreign study. . . . Cuban consulate says any group can stay in Cuba for 6 months without a passport." More disappointing was the collapse of his hopes for a one-man exhibition at The Museum of Modern Art, apparently proposed by James Johnson Sweeney, then its Director of the Department of Painting and Sculpture. In a long correspondence with a friend, Samuel Bohm, Stella reported the progress of his talks with Sweeney and made plans to bring a group of his paintings from the warehouse to the museum, but for some reason the project collapsed.

The inordinate vanity that made Stella so difficult to get along with in these years was doubtless, in some measure, a whistling in the dark, although he wore it with complete assurance. "I am more than sure that now you will be convinced that my work is in the front rank of MODERN ART," he wrote the collector Carl Weeks at the time of his exhibition at Knoedler's in 1942. "The Knoedler Gallery deals only with the best production, past and present, and my painting sustains bravely the comparison with the Flemish primitives now on display and the very best modern art, Cézanne and Seurat leading. It is imperative for you to come to New York and verify my assertion." There was something both pathetic and admirable in so sweeping a denial of defeat. These were the years when he spent his evenings at the old Waldorf Cafeteria at Sixth Avenue and 8th Street, making a cup of cocoa last from 8 to 11 o'clock, still arguing about the relative merits of Renaissance artists with Vincent Spagna, Schnitzler, Trajan, Kaldis, and others who, as Mosca recalled, "would be eventually overwhelmed by his gradually increasing decibels of voice . . . and positive statements that brooked no rebuttal." Yet it must have been worth listening to, for Stella had surprisingly keen insights into art not at all related to his own. (A single example is his manuscript article on George

Caleb Bingham, an early appreciation of that nineteenth-century American artist's "architectural structure" and the "aerial clear notes" of his color.)

As long as he could paint and talk, the buoyant optimism that was so much a part of Stella's character sustained him. But in 1942 a series of physical ills began, and with them came periods of intense depression. The first was a long attack of bronchitis that forced him to give up his studio in New York and move to an apartment in Astoria near his nephew Sergio Stella, whose mother took care of the artist. From there he wrote Mosca: "One needs a superhuman patience to endure this horrible torture. Besides I cannot sleep: I feel at night horribly nervous, and I do not know why, a real terror. To·be all day practically all alone—and not having any more the comfort of Art. Besides the idea of having to renounce the best studio I ever had—oh how terrible is all this." He had the grace to add, "My nephew and my sister-in-law are like angels to me, and I consider it great luck to have them in my misfortune. Without them I do not know what would have become of me."

In 1943 he had recovered sufficiently to take a new studio in the city, but he had hardly begun to work again when he suffered a thrombosis in his left eye, which stayed with him until his death. Again he returned to Astoria, where he wrote Mosca in April, "I am at present suffering terribly. It is not sure if my left eye will recover completely." The clot did not become worse, and Stella must have taken up his brush on a few more occasions, since there are several works dated in the following year. But his nephew remembers that he soon stopped painting completely, because he thought it would aggravate his condition. To all intents, his active career was over.

One final affliction awaited him before his death. Jurying Pepsi-Cola's "Third Portrait of America" exhibition in a storage warehouse, he walked inadvertently through the doorway of an open elevator shaft and fell some twenty feet to its bottom. Miraculously he escaped serious injury, though badly bruised and shaken, and was almost his old self until the onset of his last illness about a year later. This was mercifully swift, for, according to Mosca, Stella "feared intensely his declining physical powers, and death, or the thought of it, would literally terrify him."

"When he died," Mosca recalled, "he knew two days before it happened. There was such a childish fear in his eyes it made one weep for him. I was at his bedside the evening before he died, and I used all my wit to lift him out of this insane fear. The only thing that took him out of it was my holding, one by one, his paintings and pastels and talking about their beauty and telling him he would recover to make many more of them."

He did not, for he had suffered a serious enlargement of the heart, which

ended his life on November 5, 1946. His funeral Mass was held at Our Lady of Pompeii Church on Bleecker Street, in New York's "Little Italy." He was buried at Woodlawn Cemetery in the family vault.

Stella's departure left scarcely a ripple on the surface of the art world, except in the hearts of a few close friends. The first wave of modernism in America, to which he had so greatly contributed, had long subsided. The new abstract wave of the 1950's, which might finally have brought him recognition for his collages, had only begun to rise. His early drawings and botanical studies had been forgotten, and his role in the founding of the still active Precisionist movement had never been acknowledged. His reputation, moreover, had been clouded by the sentimental religious and symbolic canvases that had overshadowed the finer but less ambitious paintings of his late years.

Perhaps we can now begin to see Stella whole and, while admitting the emotional excesses that often afflicted his art, recognize his creative stature. This, it is apparent, rests on no single, easily defined achievement but on the very multiplicity of his talents: the superb draftsmanship, the formidable skill with which he transformed Futurism into a peculiarly American kind of modernism, the sensibility that responded equally to industrial forms and city debris, the wild imagination that created a handful of truly compelling dreams and fantasies. He belongs to no school or movement, defies classification; there is no painter at all like him in the whole of American art.

ILLUSTRATIONS

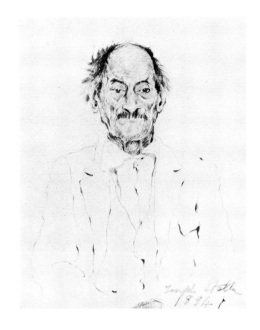

Left
1. *Italian Peasant.* 1894. Red ink. 4⅞ x 4 inches. Collection of Sergio Stella, Glen Head, New York.

Below
2. *Italian Immigrant.* 1898. Pencil. 8¾ x 7½ inches. Collection of Stanley Ross, Maplewood, New Jersey.

Opposite
3. *Nude. Ca.* 1900. Oil. 27 x 15 inches. Collection of Sergio Stella, Glen Head, New York.

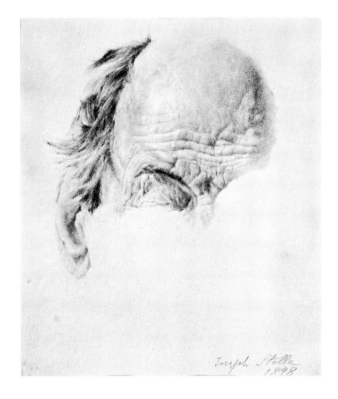

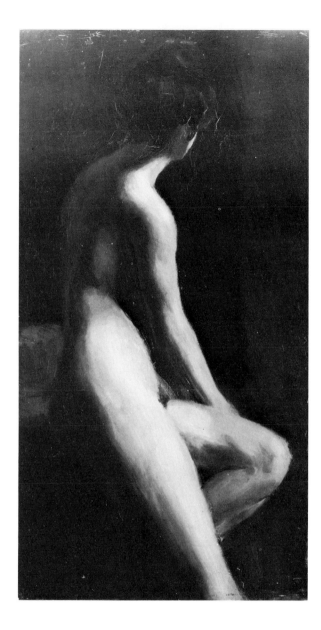

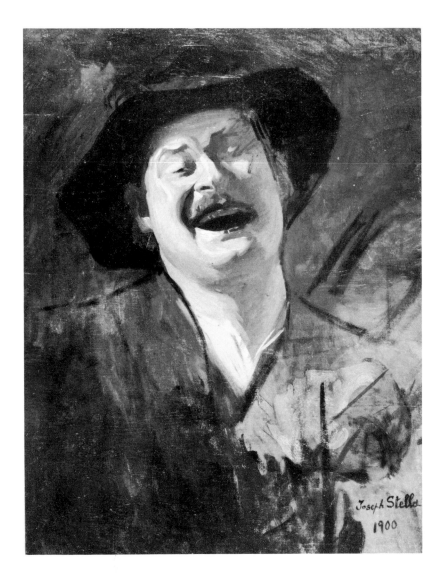

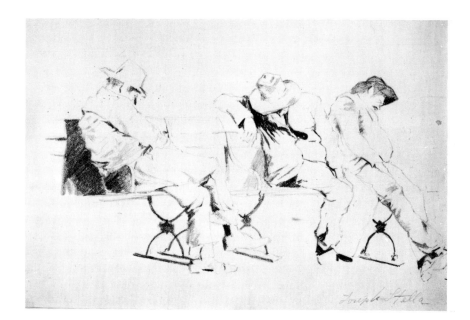

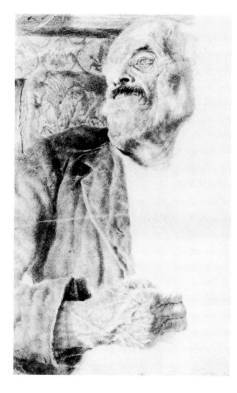

Opposite
4. *Laughing Man.* 1900. Oil. 26¼ x 20¼ inches (sight). Collection of the Estate of Joseph Stella.

Above
5. *Three Men on a Bench. Ca.* 1907. Pencil. 5¹¹⁄₁₆ x 8¾ inches. Collection of Mr. and Mrs. Herbert A. Goldstone, New York.

Right
6. *Italian Immigrant. Ca.* 1907. Pencil. 14 x 9 inches (sight). Collection of Edgar Kaufmann, jr., New York.

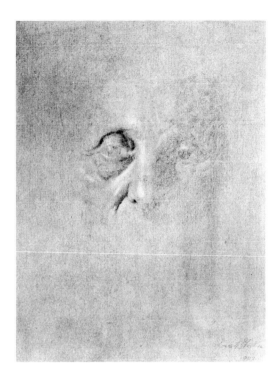

Above
7. *Face of an Elderly Person*. 1907. Charcoal and chalk. 9½ x 7½ inches (sight). Rabin and Krueger Gallery, Newark, New Jersey.

8. *The Cripple*. *Ca*. 1908. Pencil. 11½ x 7⅞ inches. Collection of Dr. and Mrs. Franklin Simon, Millburn, New Jersey.

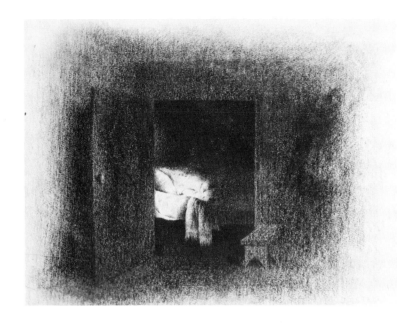

9. *Dark Bedroom. Ca.* 1908. Charcoal. 12½ x 16½ inches. Collection of Sergio Stella, Glen Head, New York.

Below
10. *Mill Interior. Ca.* 1908. Charcoal. 13½ x 17¾ inches. Collection of Mr. and Mrs. Herbert A. Goldstone, New York.

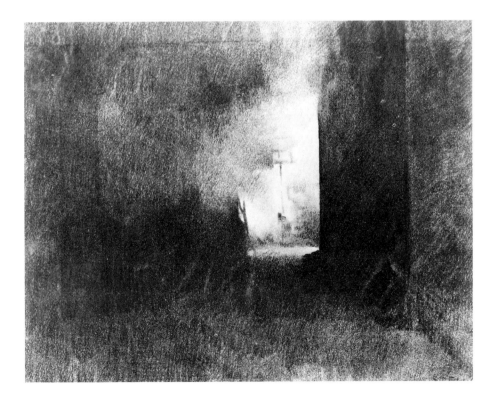

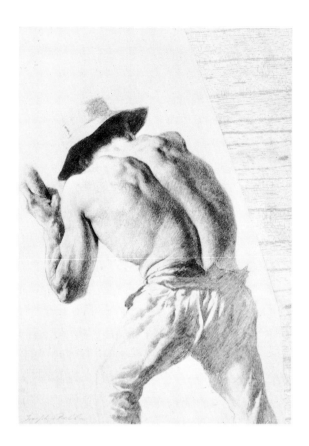

Above
11. *Back of a Man Working. Ca.* 1908. Pencil. 9¼ x
6⅝ inches. Rabin and Krueger Gallery, Newark, New
Jersey.

12. *Working Man.* 1908. Pencil. 8 x 6 inches. Joseph
H. Hirshhorn Collection, New York.

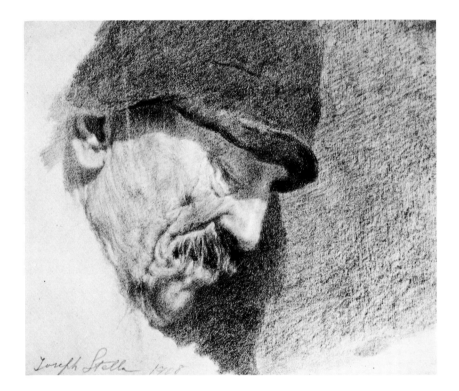

13. *Head of a Miner, Resting.* 1908. Pencil. 7⅛ x 8¼ inches.
Collection of Mr. and Mrs. Emanuel M. Terner, New York.

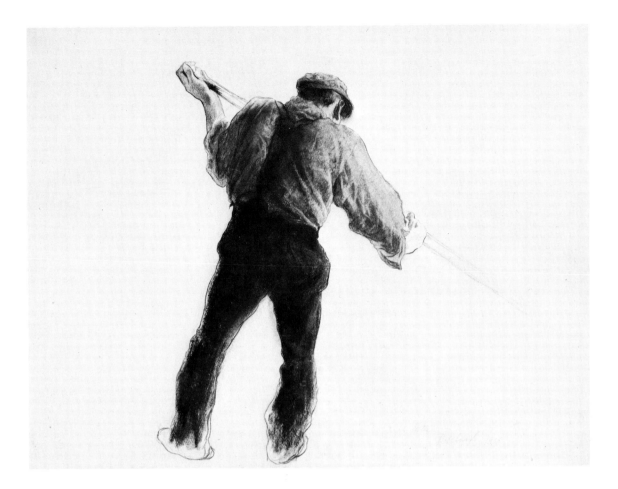

14. *The Puddler*. 1908. Charcoal and pastel. 19 x 26 inches.
Collection of Mr. and Mrs. Walter Fillin, Rockville Centre, New York.

15. *Head of Woman*. 1908. Charcoal and pastel. 19 x 15 inches (sight). Collection of Sergio Stella, Glen Head, New York.

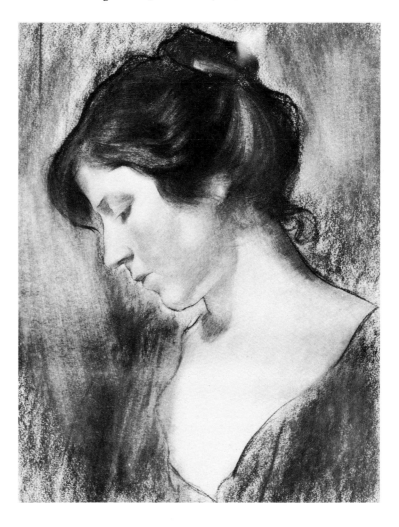

16. *Italian Leader (Portrait)*. 1908. Conté crayon. 23½ x 19
inches. Collection of Mr. and Mrs. Maurice Vanderwoude,
Great Neck, New York.

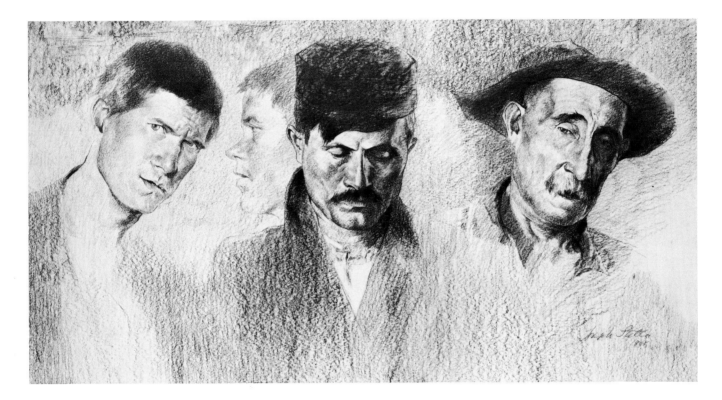

17. *Four Miners.* 1908. Charcoal. 18¼ x 34⅜ inches.
Collection of Mr. and Mrs. Caesar P. Kimmel, Livingston, New Jersey.

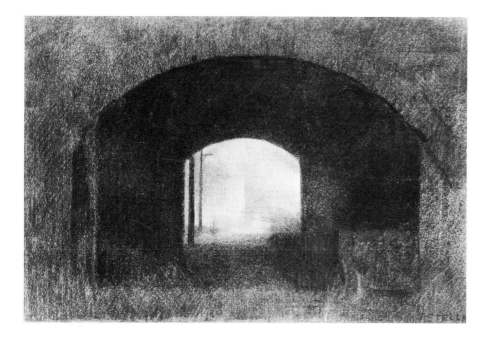

Above
18. *Underpass.* 1908. Charcoal. 11¼ x 16¼ inches. Private collection.

19. *Pittsburgh, Winter.* 1908. Charcoal. 17¾ x 24 inches.
Collection of Rita and Daniel Fraad, Scarsdale, New York.

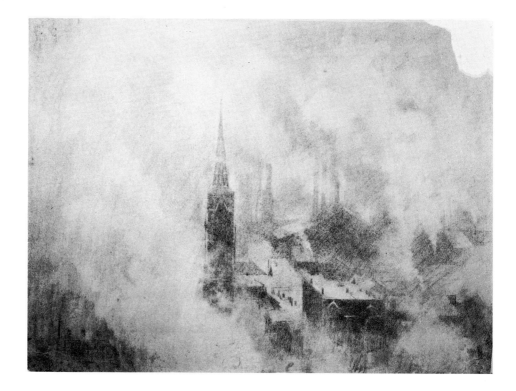

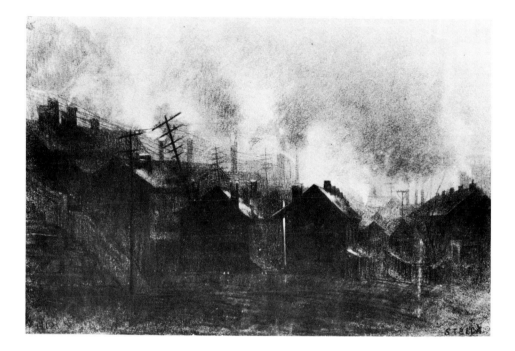

20. *Pittsburgh, Workers' Houses*. 1908. Charcoal. 12 x 18¼ inches.
Collection of Angela N. Gross, Maplewood, New Jersey.

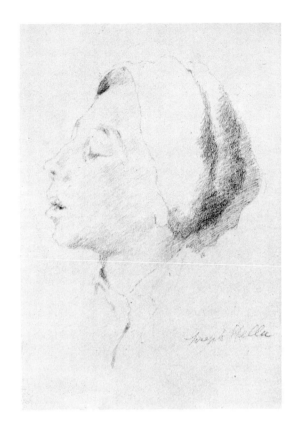

Left
21. *Woman's Head. Ca.* 1910. Pencil. 5 x 3½ inches. Collection of Paul Magriel, New York.

22. *Profile of a Woman.* 1909. Chalk and crayon. 10½ x 9½ inches. Rabin and Krueger Gallery, Newark, New Jersey.

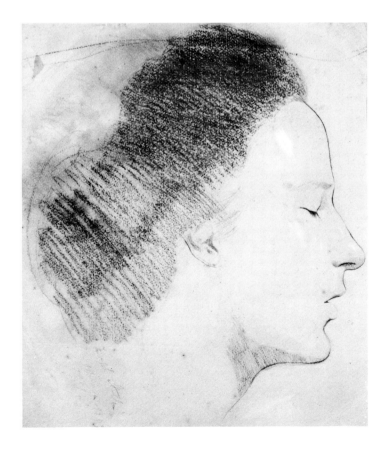

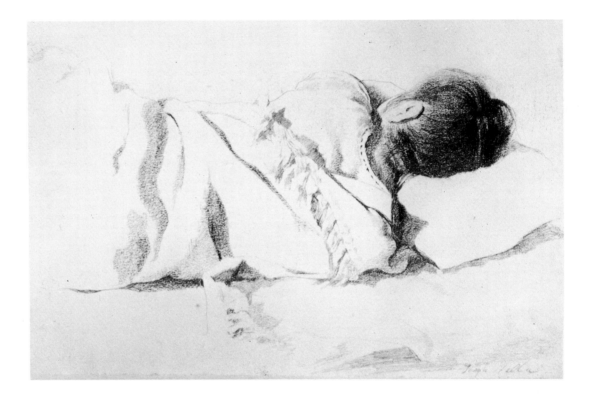

23. *Back of a Woman, Sleeping. Ca.* 1910. Pencil. 5½ x 8¼ inches.
Collection of Mr. and Mrs. Raymond J. Horowitz.

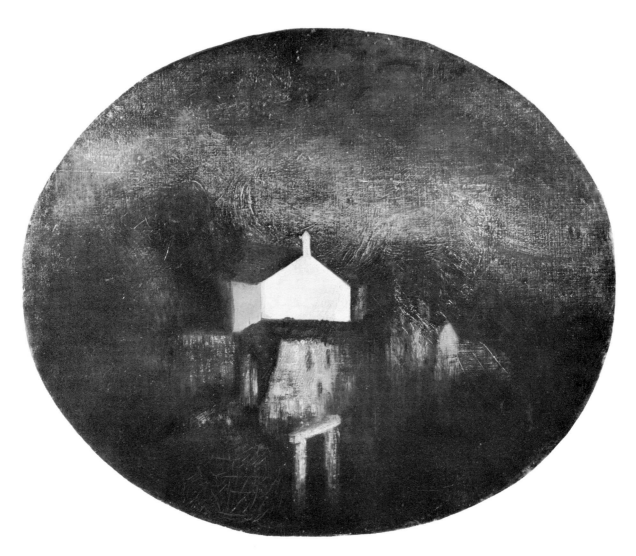

24. *Italian Church. Ca.* 1910. Oil. 22¼ x 28¾ inches.
Joseph H. Hirshhorn Foundation, New York.

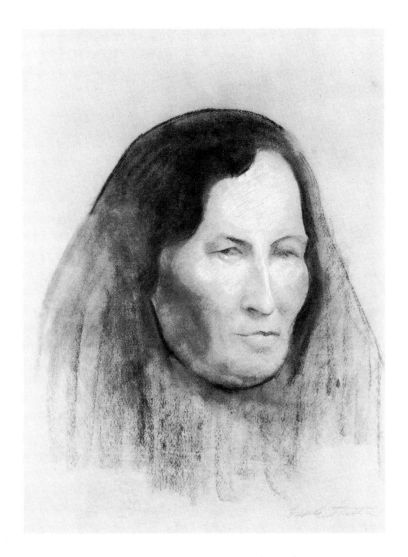

25. *Head of a Woman. Ca.* 1910. Charcoal and pastel.
22¼ x 19 inches (sight).
Collection of Mrs. Samuel Shore, New York.

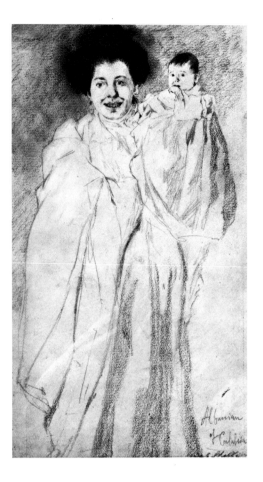

Left
26. *Albanian Mother and Child. Ca.* 1910–12. Crayon. 13¾ x 7⅞ inches.
Rabin and Krueger Gallery, Newark, New Jersey.

27. *Mother and Child. Ca.* 1910–12. Charcoal and sanguine. 24⅛ x 20 inches.
Collection of Mr. and Mrs. Hy Temkin, West Orange, New Jersey.

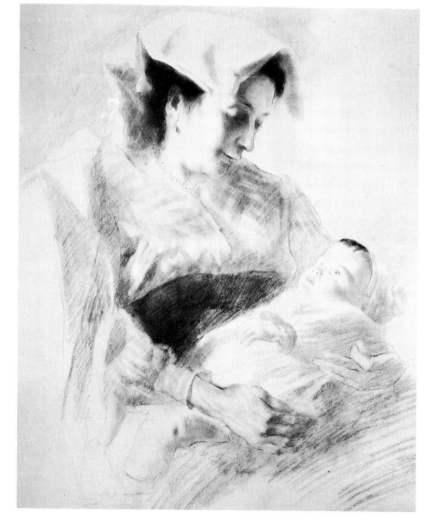

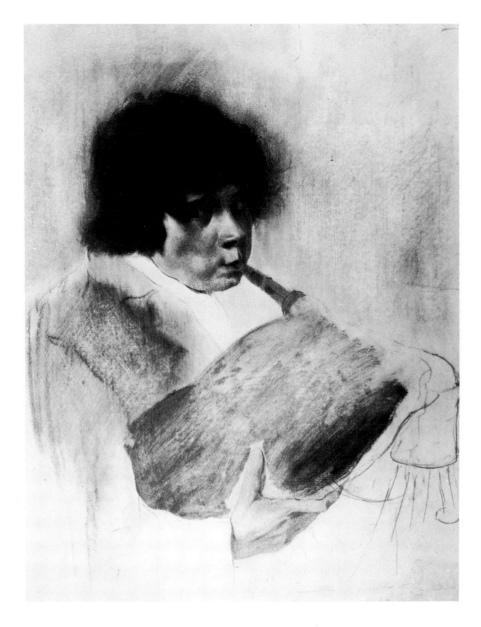

28. *Boy with Bagpipe. Ca.* 1910–12. Pencil. 21¾ x 16 inches.
Collection of Mr. and Mrs. Walter Fillin, Rockville Centre, New York.

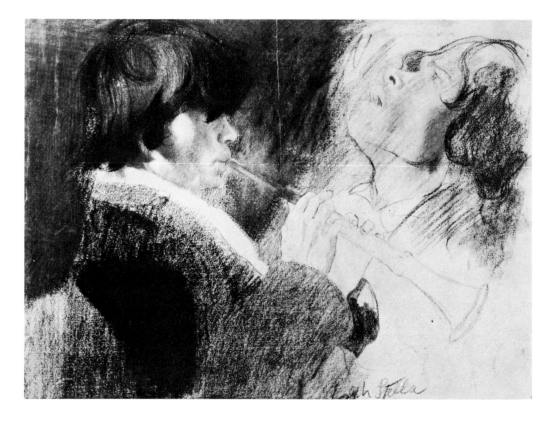

29. *Boy Playing Wind Instrument. Ca.* 1910. Charcoal and sanguine. 14½ x 19½ inches.
Collection of Mr. and Mrs. Herbert A. Goldstone, New York.

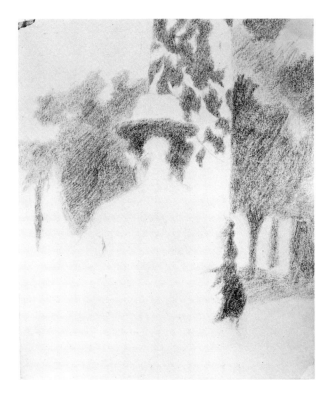

Left

30. *Man Seen from the Rear. Ca.* 1912. Crayon. 8 x 6⅞ inches.
Gallery 6M, New York.

31. *Bearded Old Man. Ca.* 1912. Monoprint.
13¼ x 11⅜ inches.
Collection of Sergio Stella, Glen Head, New York.

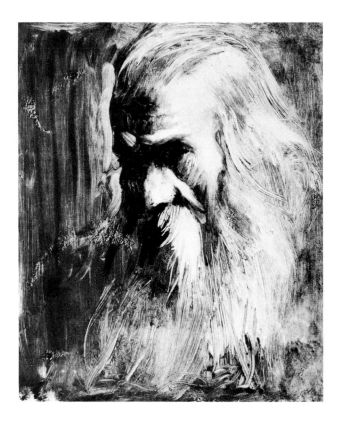

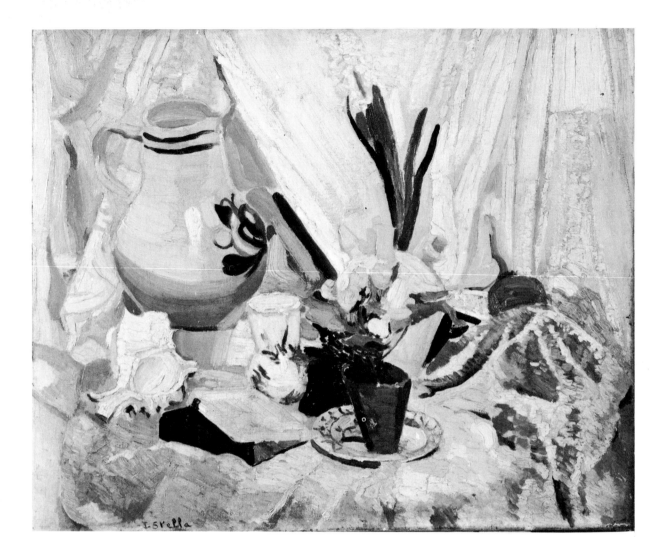

32. *Still Life. Ca.* 1912. Oil. 23¼ x 28¼ inches.
Collection of Alan Silber, New York.

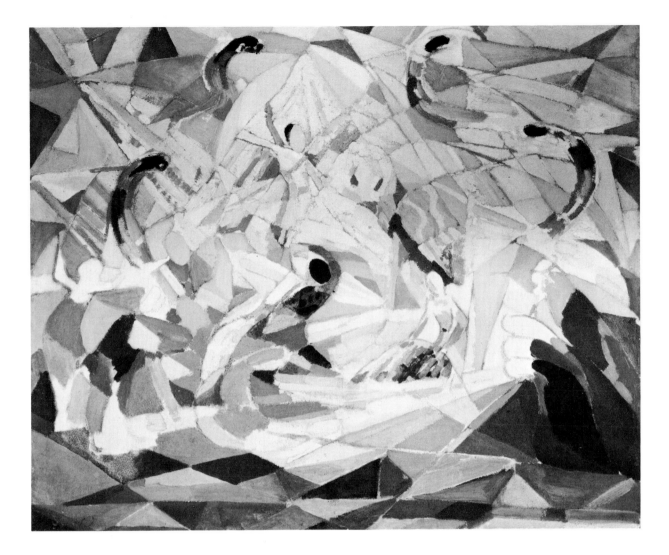

33. *Der Rosenkavalier.* 1913–14. Oil. 24 x 30 inches.
Whitney Museum of American Art, New York; gift of George F. Of.

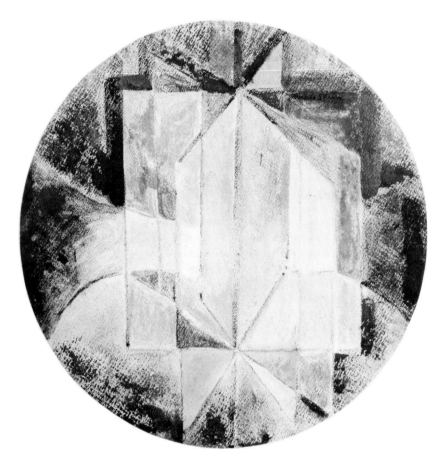

34. *Abstraction. Ca.* 1913–14. Pastel. 11½ inches in diameter.
Collection of Mrs. Edith Gregor Halpert, New York.

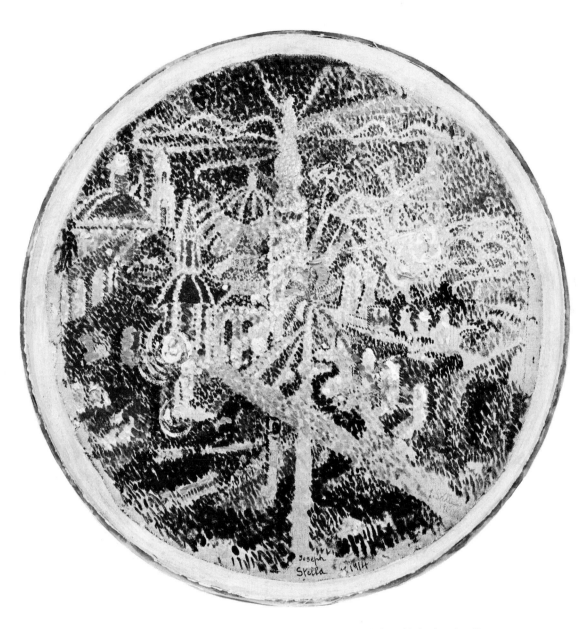

35. *Study for Battle of Lights, Coney Island.* 1913–14. Oil. 20¼ inches in diameter.
The Museum of Modern Art, New York; Elizabeth Bliss Parkinson Fund.

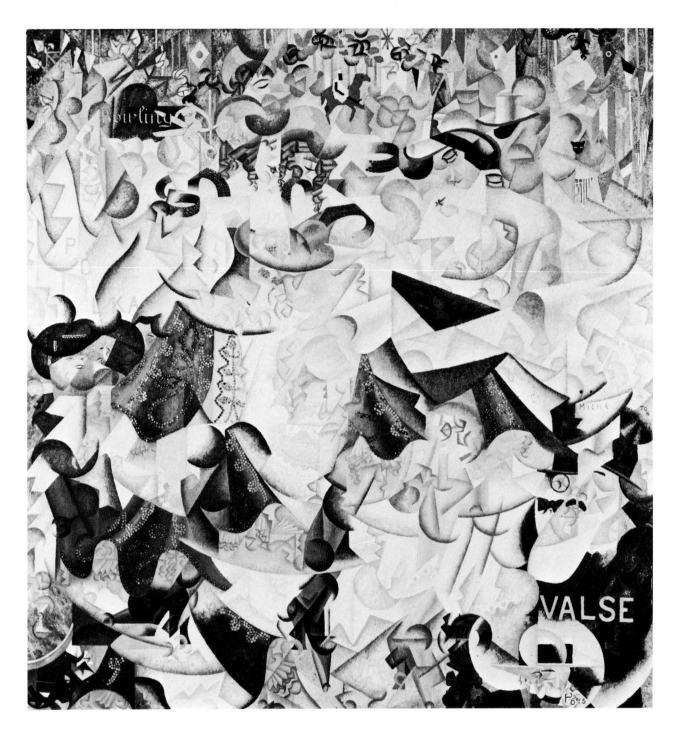

36. Gino Severini: *Dynamic Hieroglyphic of the Bal Tabarin*. 1912. Oil with sequins.
63⅝ x 61½ inches.
The Museum of Modern Art, New York; acquired through the Lillie P. Bliss Bequest.

37. *Abstraction, Garden. Ca.* 1914. Pastel. 18⅛ x 24 inches (sight).
Rabin and Krueger Gallery, Newark, New Jersey.

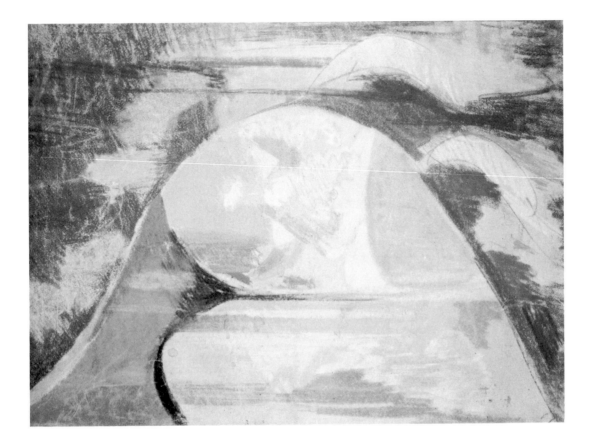

38. *Abstraction. Ca.* 1914. Pastel. 19 x 25½ inches.
Woodward Foundation, Washington, D.C.

39. *Composition*. 1914. Pastel. 25 x 19 inches.
Collection of Mrs. Edith Gregor Halpert, New York.

40. *Sunlight and Water.* 1914. Pastel. 17 x 22¼ inches (sight).
Collection of Mr. and Mrs. Emanuel M. Terner, New York.

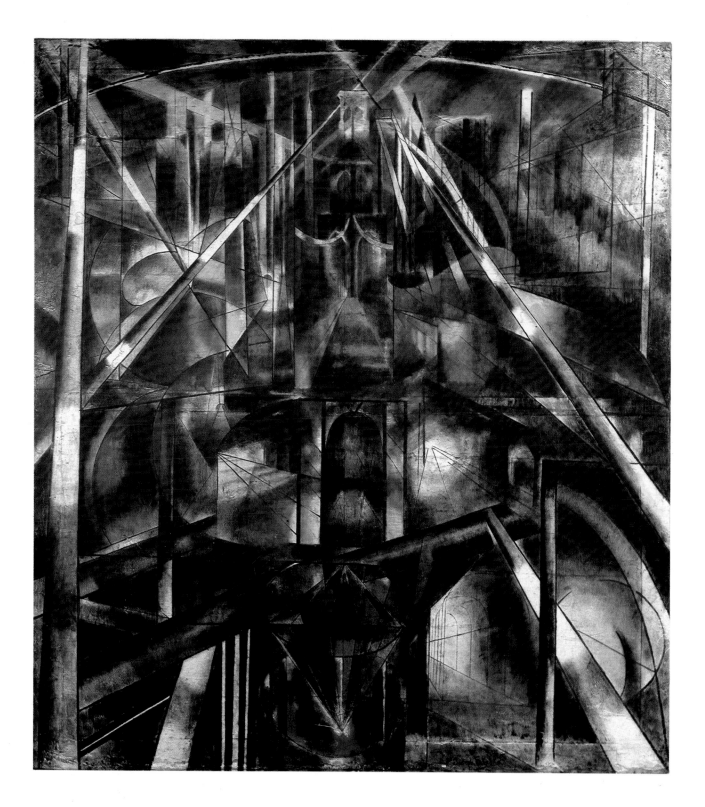

PLATE V. *Brooklyn Bridge. Ca.* 1919. Oil. 84 x 76 inches.
Yale University Art Gallery, New Haven; Collection Société Anonyme

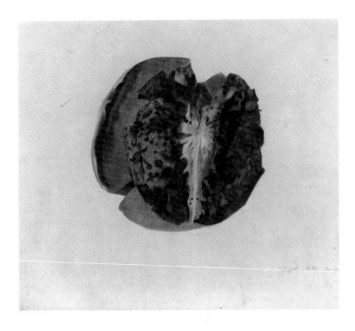

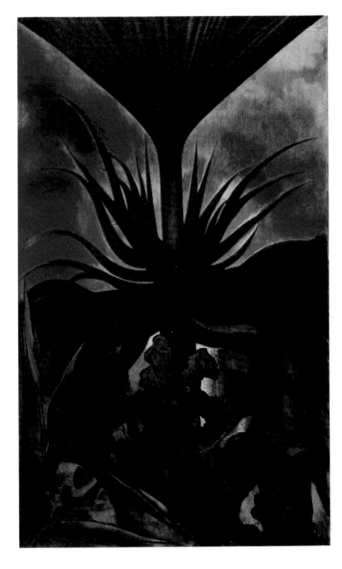

Above
PLATE VI. *Pomegranate.* 1919. Crayon. 14 x 18 inches.
Rabin and Krueger Gallery, Newark, New Jersey.

PLATE VII. *Tropical Sonata.* 1920–21. Oil. 48 x 29 inches.
Whitney Museum of American Art, New York.

41. *Old Brooklyn Houses.* 1914. Pastel. 19½ x 27 inches.
Collection of the Estate of Joseph Stella.

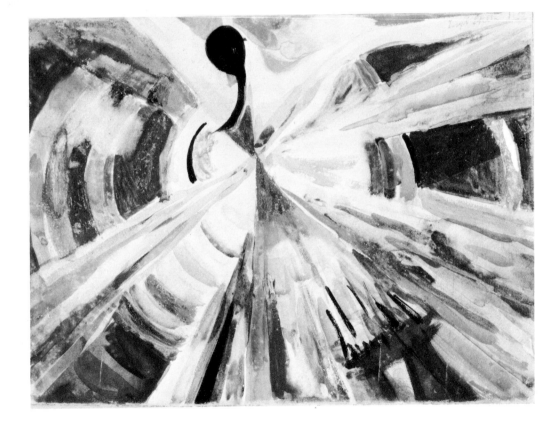

42. *Composition, Mardi Gras. Ca.* 1915. Watercolor and gouache. 8¾ x 11½ inches.
Joseph H. Hirshhorn Collection, New York.

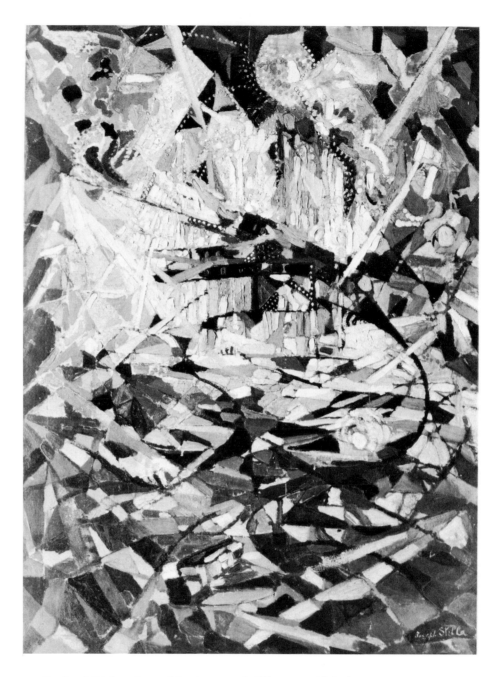

43. *Battle of Lights, Coney Island.* 1914–18. Oil. 39 x 29½ inches.
F. M. Hall Collection, University of Nebraska, Lincoln, Nebraska.

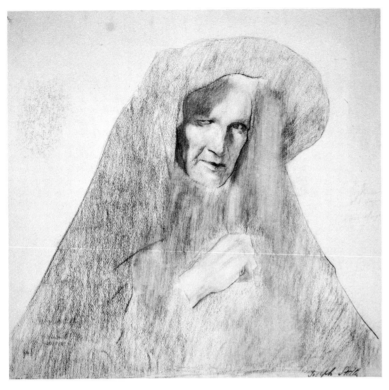

Left

44. *Serbian Woman. Ca.* 1917. Charcoal and pastel. 18 x 19 inches. The Art Institute of Chicago, Chicago, Illinois.

45. *Factories. Ca.* 1918. Pastel and charcoal. 21½ x 27½ inches. Joseph H. Hirshhorn Collection, New York.

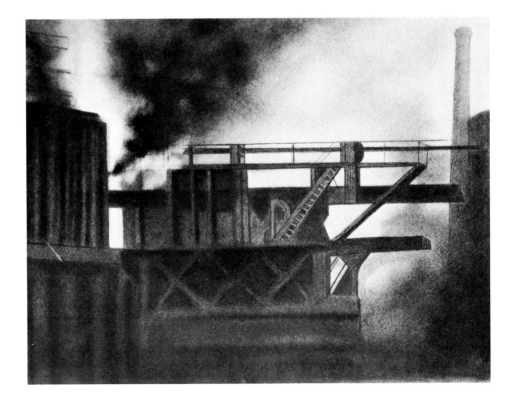

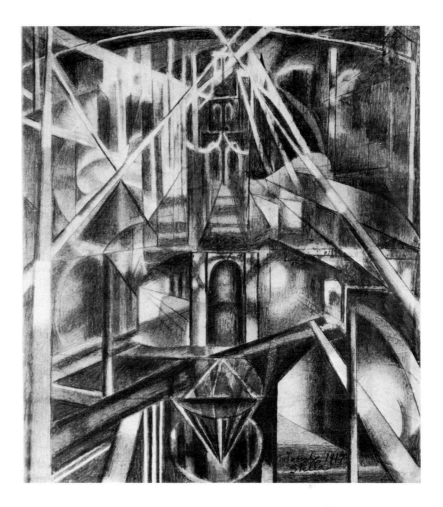

46. *Study for Brooklyn Bridge.* 1917. Pencil and sepia wash.
17 x 15½ inches.
Collection of Hilde L. Mosse, New York.

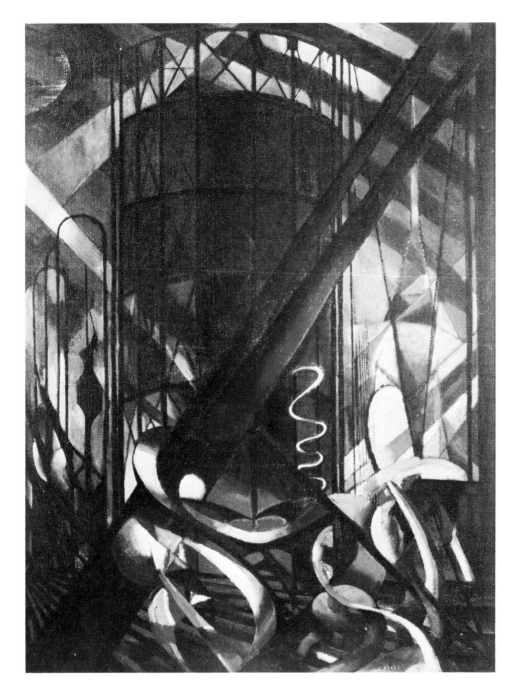

47. *The Gas Tank*. 1918. Oil. 40½ x 30 inches.
Collection of Mr. and Mrs. Roy R. Neuberger, New York.

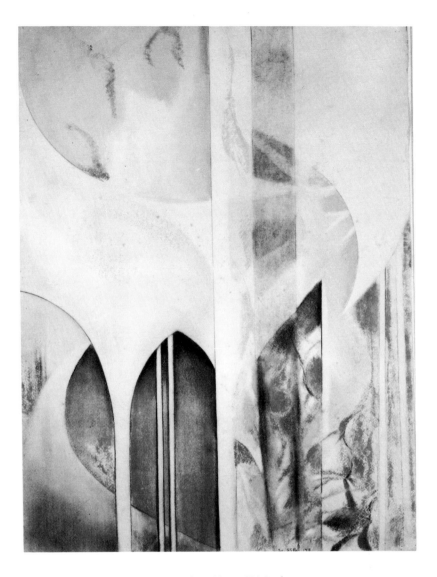

48. *A Child's Prayer*. 1918. Pastel. 23½ x 18¼ inches.
Collection of the Estate of Isabel Lachaise.

Left

49. *Lupine. Ca.* 1919. Pastel. 27½ x 21½ inches (sight). Collection of Robert Tobin, San Antonio, Texas.

50. *Seated Woman.* 1919. Ink. 7⅛ x 5⅜ inches. Collection of Sergio Stella, Glen Head, New York.

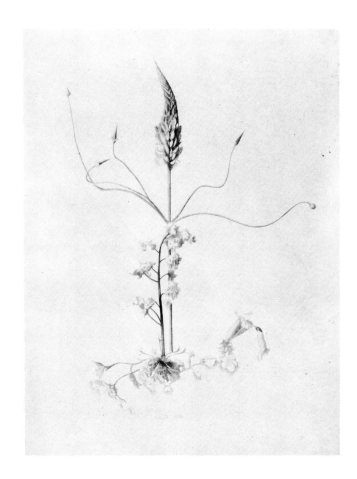

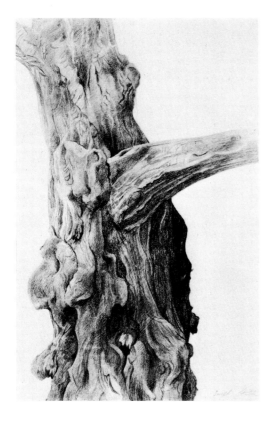

Above
51. *Tree Trunk*. *Ca.* 1919. Crayon. 16½ x 11 inches. Rabin and Krueger Gallery, Newark, New Jersey.

52. *Sunflower*. *Ca.* 1919. Crayon. 28½ x 21¾ inches. Collection of Sergio Stella, Glen Head, New York.

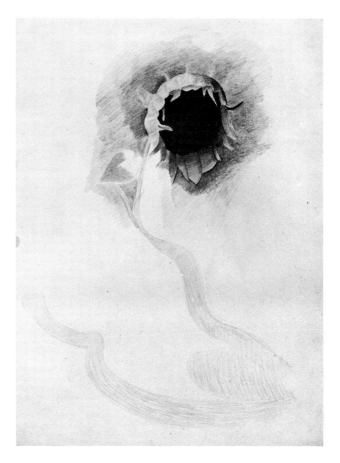

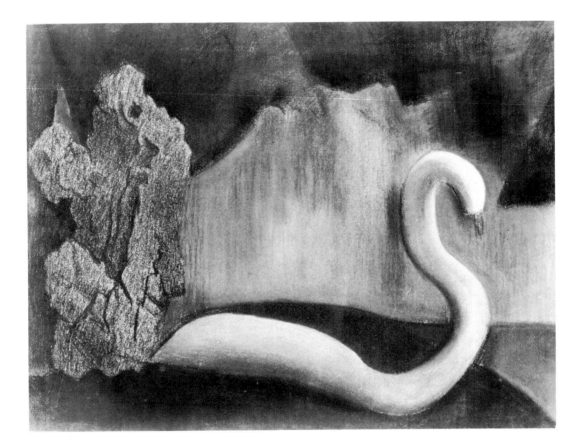

53. *Fantasy with Zucchini. Ca.* 1919. Pastel. 18 x 24 inches (sight).
Collection of the Estate of Joseph Stella.

54. *Bridge and Buildings. Ca.* 1919. Watercolor. 28½ x 21⅛ inches.
Collection of Mr. and Mrs. Emanuel M. Terner, New York.

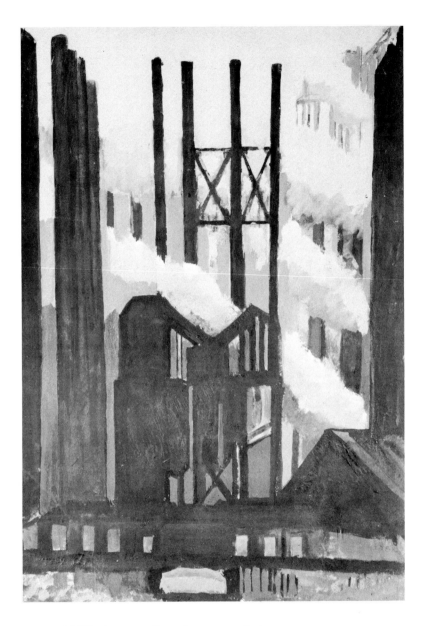

55. *Steel Mill. Ca.* 1920. Gouache. 17 x 12 inches.
The Downtown Gallery, New York.

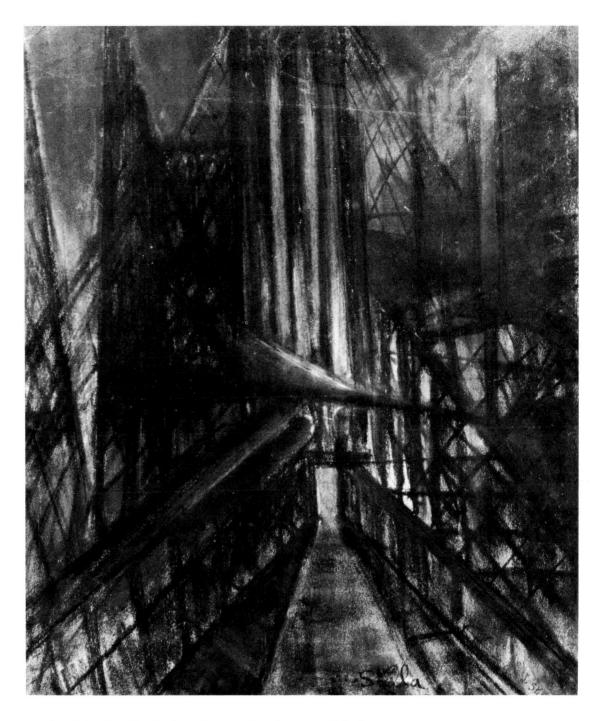

56. *Sketch for Brooklyn Bridge. Ca.* 1920. Pastel. 21 x 17½ inches.
Whitney Museum of American Art, New York; gift of Miss Rose Fried.

57. *Building Forms. Ca.* 1920. Watercolor. 24¼ x 17¾ inches.
Joseph H. Hirshhorn Collection, New York.

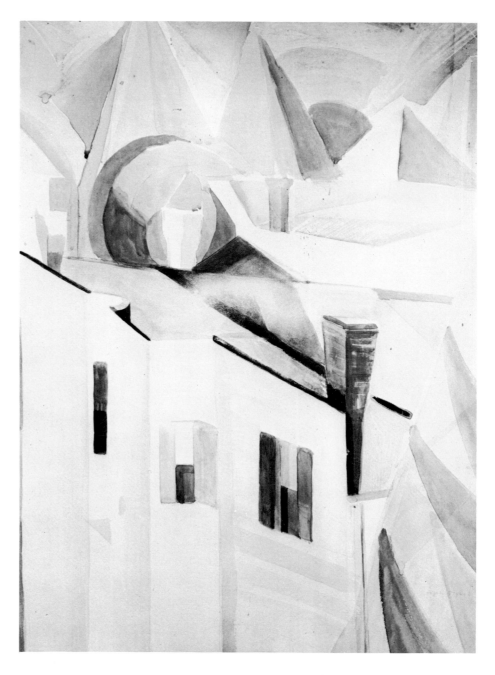

58. *Paris, Rooftops. Ca.* 1920. Watercolor. 21⅝ x 16¾ inches.
Collection of Jon Nicolas Streep.

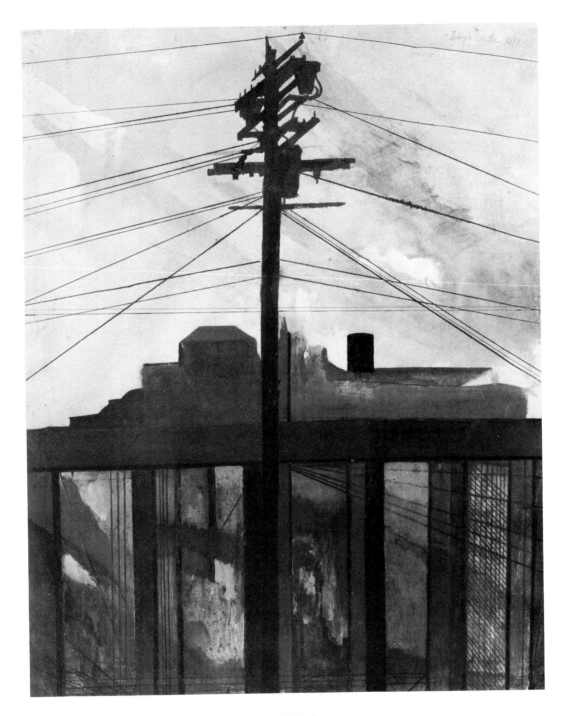

59. *Telegraph Pole. Ca.* 1920. Gouache. 24½ x 19½ inches.
Collection of Mr. and Mrs. Meyer P. Potamkin, Philadelphia, Pennsylvania.

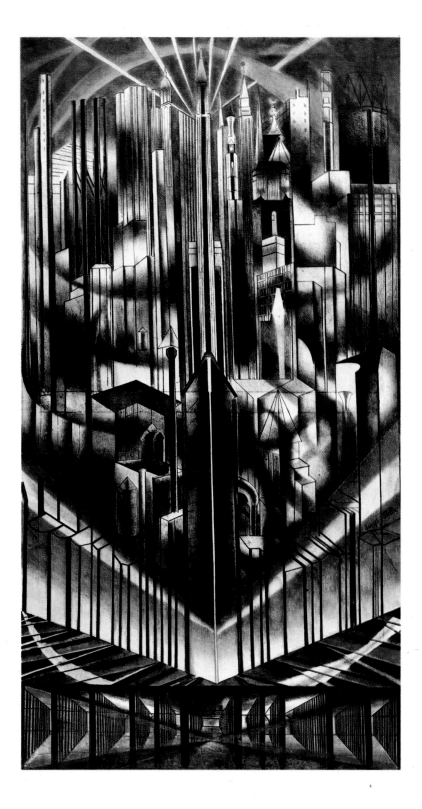

PLATE VIII. *New York Interpreted: The Skyscrapers.* 1920–22.
Oil. 99¾ x 54 inches.
The Newark Museum, Newark, New Jersey.

Below

PLATE IX. *The Red Flower*. 1929. Oil. 57½ x 38½ inches.
Collection of the Estate of Joseph Stella.

PLATE X. *Collage, Number 21*. n.d. 10½ x 7½ inches.
Whitney Museum of American Art, New York.

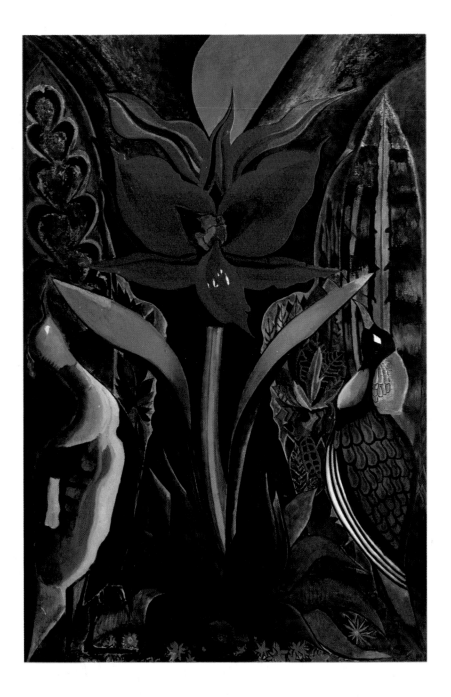

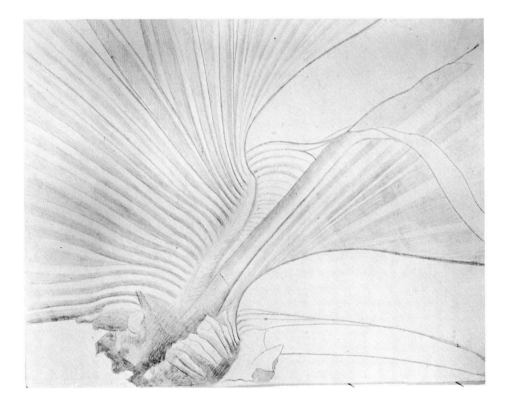

60. *Palm Fronds. Ca.* 1920–21. Silverpoint. 8⅜ x 10⅞ inches.
Collection of Sergio Stella, Glen Head, New York.

61. *Portrait of Eilshemius.* 1920. Silverpoint. 22¾ x 18½ inches.
Joseph H. Hirshhorn Collection, New York.

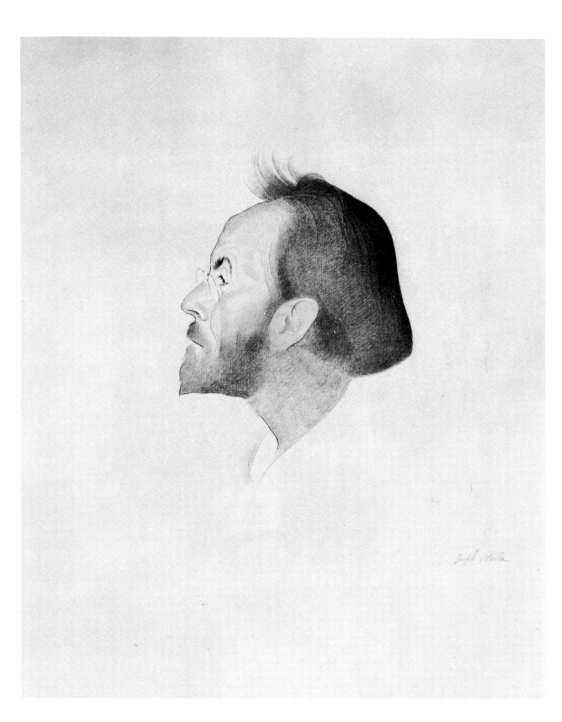

62. *Louis Eilshemius. Ca.* 1920. Pencil. 28⅜ x 21⅝ inches.
Whitney Museum of American Art, New York.

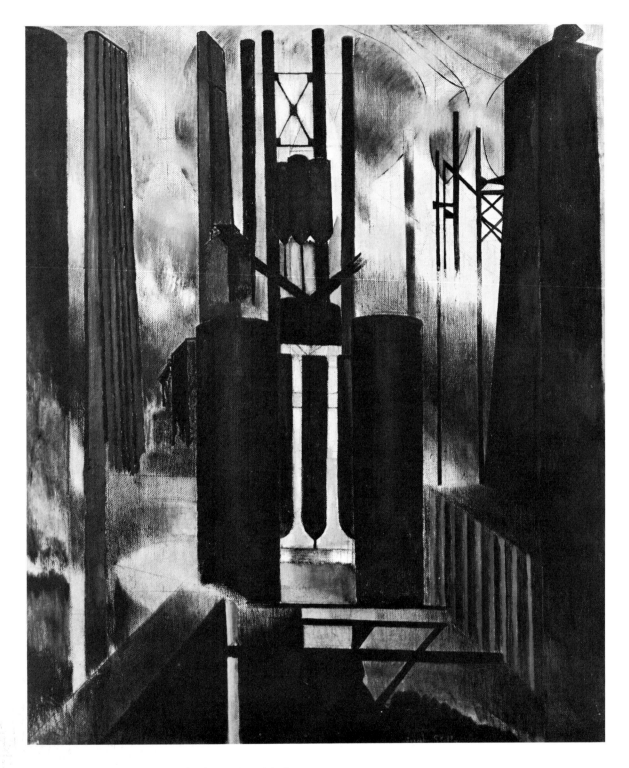

63. *Factories. Ca.* 1921. Oil on burlap. 56 x 46 inches.
The Museum of Modern Art, New York; acquired through the Lillie P. Bliss Bequest.

64. *Smoke Stacks. Ca.* 1921. Oil. 36 x 30 inches.
Art Department, Indiana State College, Terre Haute, Indiana.

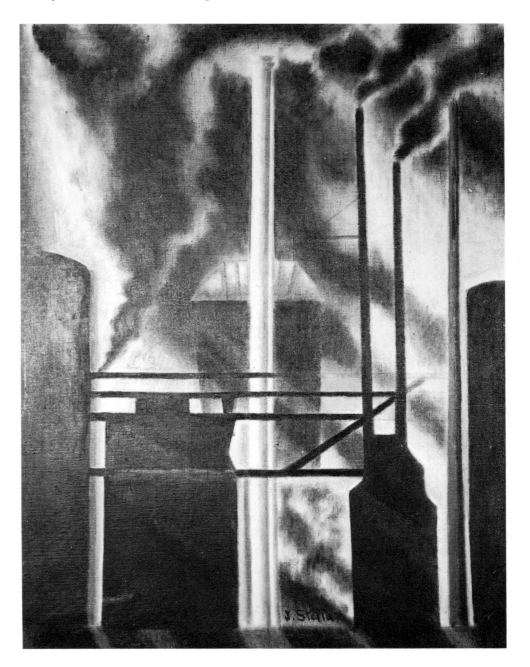

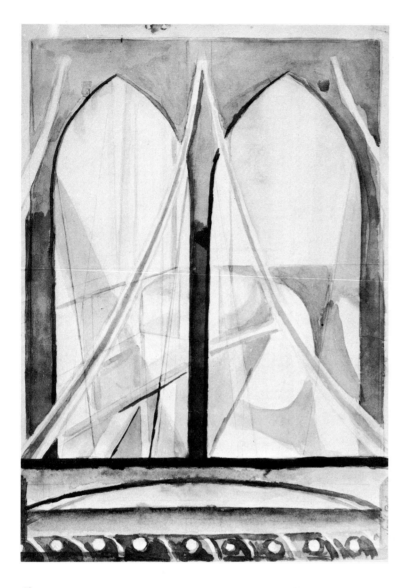

Above
65. *Study for New York Interpreted: The Bridge. Ca.* 1920–22.
Watercolor. 23 x 17 inches.
The Downtown Gallery, New York.

Opposite
66. *New York Interpreted: The Port.* 1920–22. Oil. 88½ x 54 inches.
The Newark Museum, Newark, New Jersey.

Overleaf
67. *New York Interpreted: The White Way, I.* 1920–22. Oil. 88½ x 54 inches.
The Newark Museum, Newark, New Jersey.

68. *New York Interpreted: The White Way, II.* 1920–22. Oil. 88½ x 54 inches.
The Newark Museum, Newark, New Jersey.

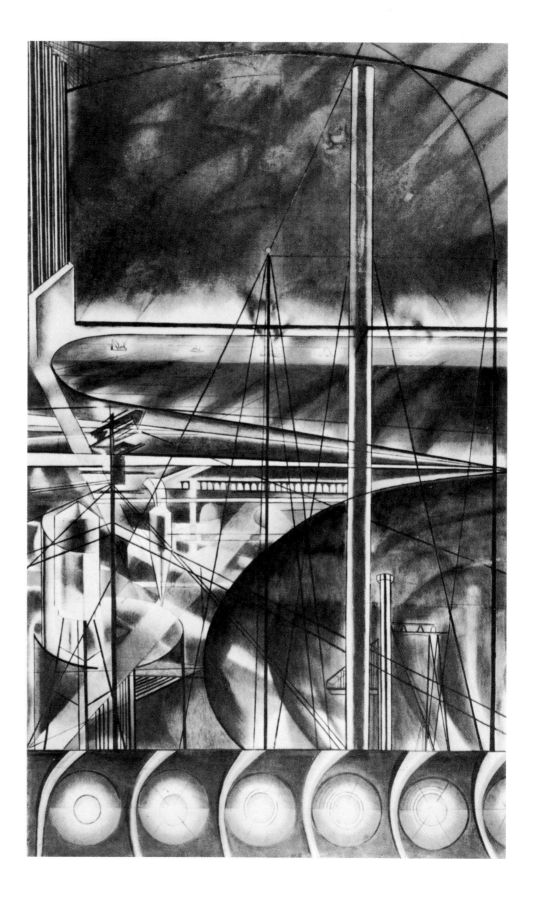

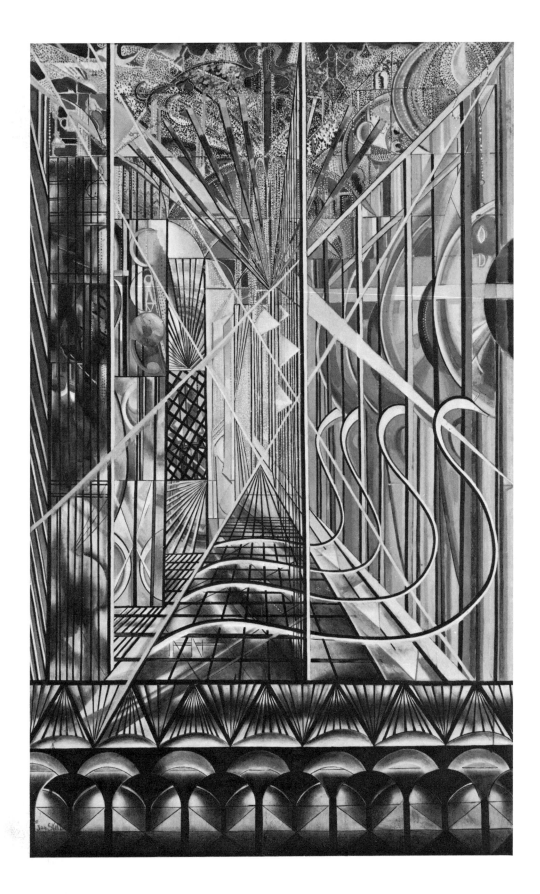

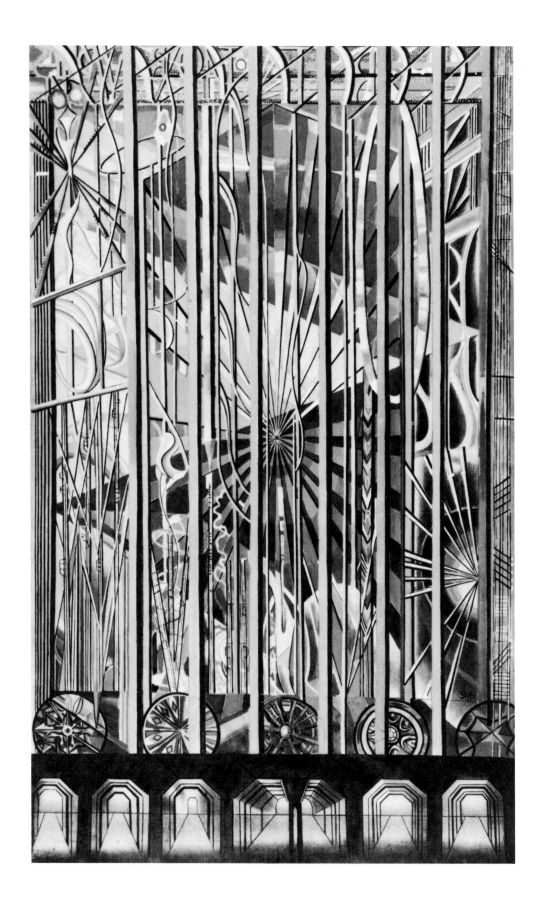

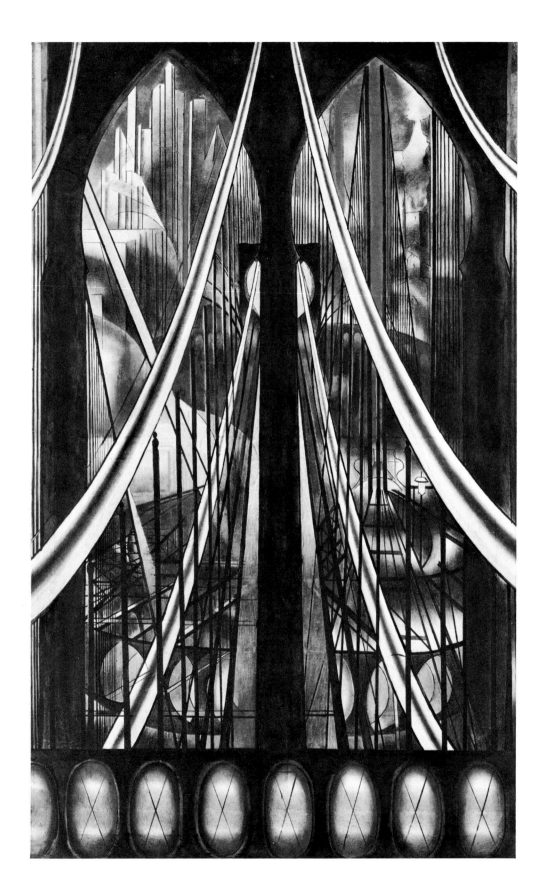

Opposite
69. *New York Interpreted: The Bridge.* 1920–22. Oil. 88½ x 54 inches. The Newark Museum, Newark, New Jersey.

Above
70. *Collage Number 4, The Bookman.* 1920–22. 7 x 4½ inches. Joseph H. Hirshhorn Collection, New York.

Right
71. *Collage, Conjunction Number 5.* n.d. 12 x 9 inches. Collection of Mr. and Mrs. Merle Litt, Chicago, Illinois.

72. *Collage Number 20, Red Seal*. n.d. 18 x 12 inches.
Collection of Virginia Zabriskie, New York.

73. *Collage, Leaf.* n.d. 11 x 8½ inches.
Richard Gray Gallery, Chicago, Illinois.

74. *Collage, Gray and Orange.* n.d. 10 x 8⅜ inches.
Collection of Mr. and Mrs. Volney Righter,
Bedford Hills, New York.

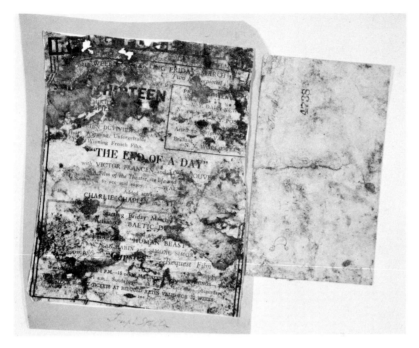

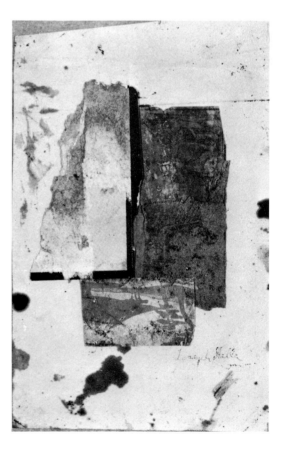

Above
75. *Collage, The End of a Day.* n.d. 8⅜ x 10¼ inches.
Private collection.

76. *Collage, Number 14.* n.d. 9 x 6 inches.
Collection of Ulrich Franzen, New York.

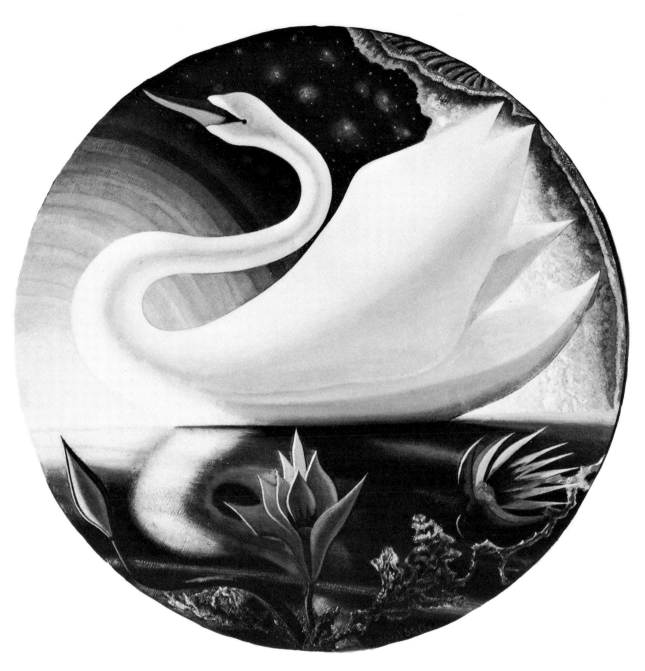

77. *The Swan. Ca.* 1924. Oil. 45 inches in diameter.
Collection of the Estate of Joseph Stella.

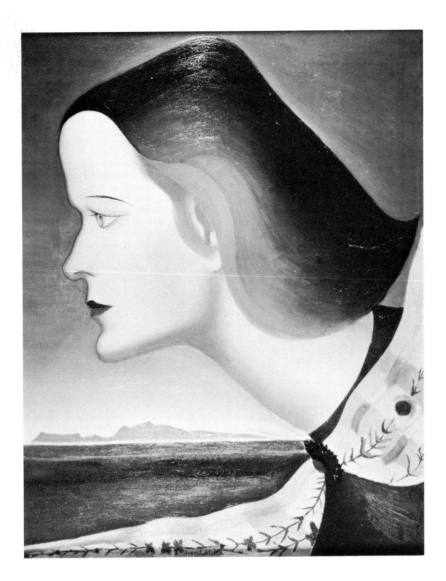

78. *The Amazon*. 1924. Oil. 27 x 22 inches.
A.C.A. Gallery, New York.

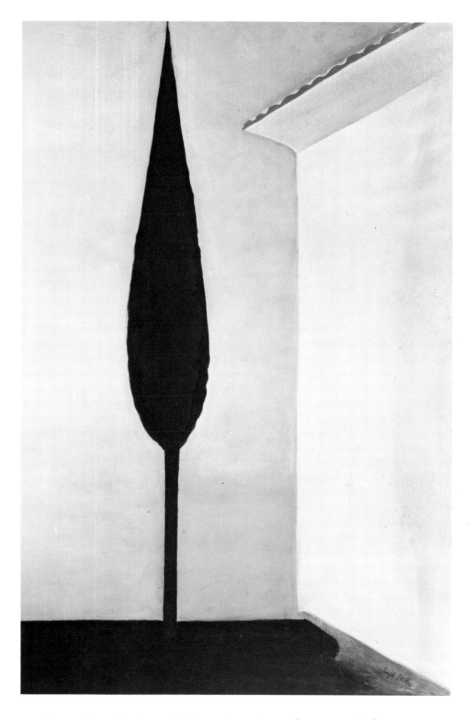

79. *Cypress Tree. Ca.* 1927–28. Watercolor and gouache. 41 x 27 inches.
Joseph H. Hirshhorn Collection, New York.

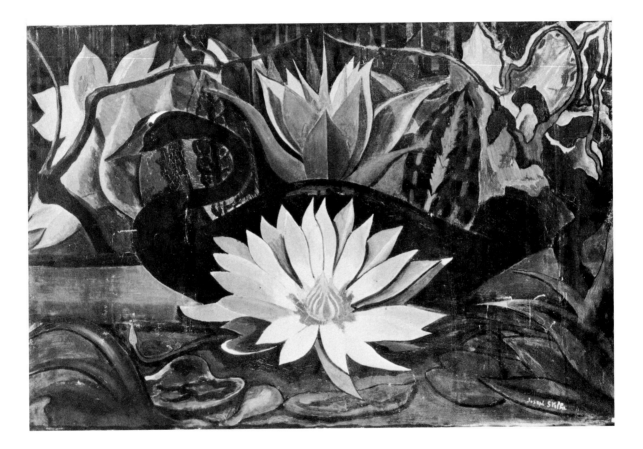

80. *Black Swan. Ca.* 1928. Oil. 20¾ x 31 inches.
Collection of the Estate of Joseph Stella.

81. *Muro Lucano*. 1928. Oil. 32 x 25¾ inches.
Collection of Lawrence H. Bloedel, Williamstown, Massachusetts.

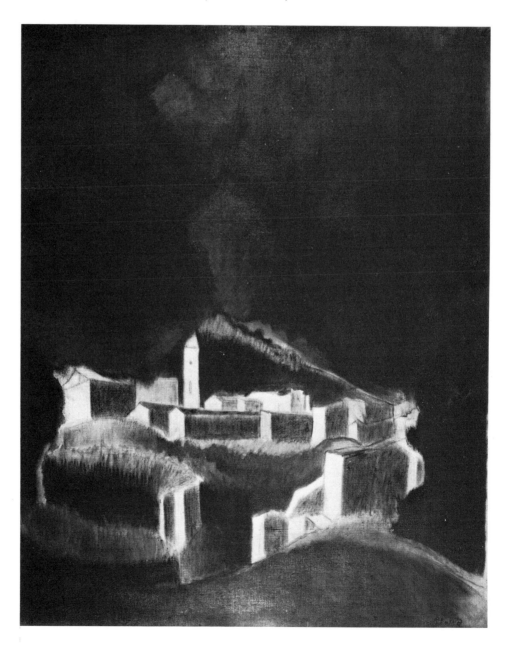

82. *Self-portrait. Ca.* 1929. Watercolor and wax. 20 x 15½ inches.
Collection of Mr. and Mrs. Herbert A. Goldstone, New York.

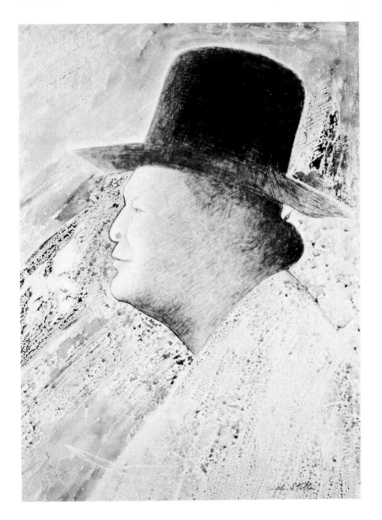

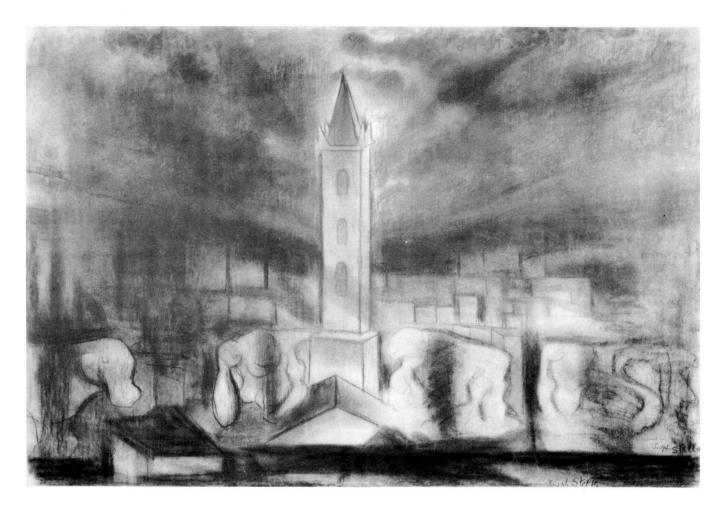

83. *Nocturne. Ca.* 1929. Pastel. 38¼ x 58¾ inches.
Joseph H. Hirshhorn Collection, New York.

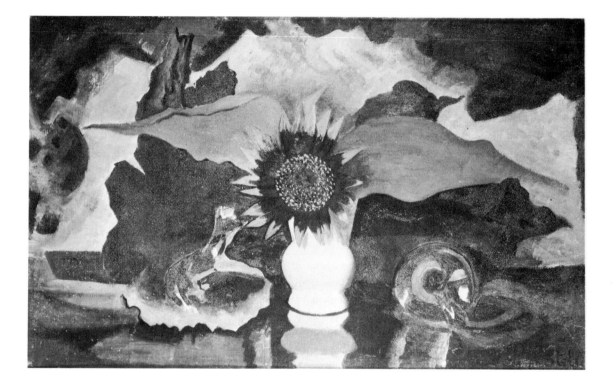

84. *Still Life. Ca.* 1929. Oil. 15 x 24¼ inches.
Whitney Museum of American Art; gift of Mr. and Mrs. N. E. Waldman.

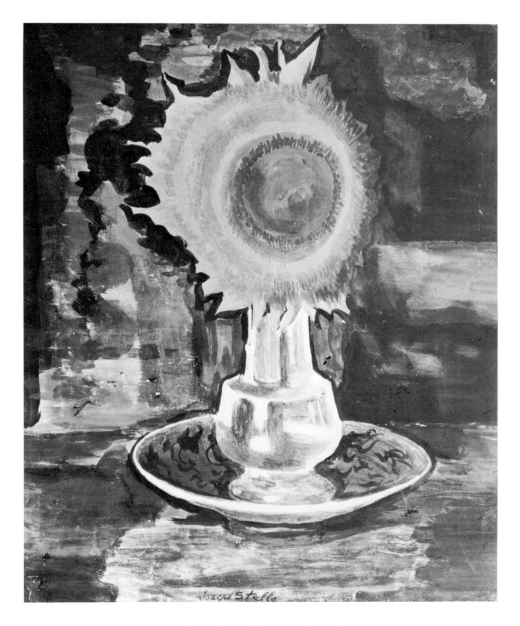

85. *Sunflower. Ca.* 1929. Gouache. 21⅞ x 18¼ inches (sight).
Collection of Mr. and Mrs. Emanuel M. Terner.

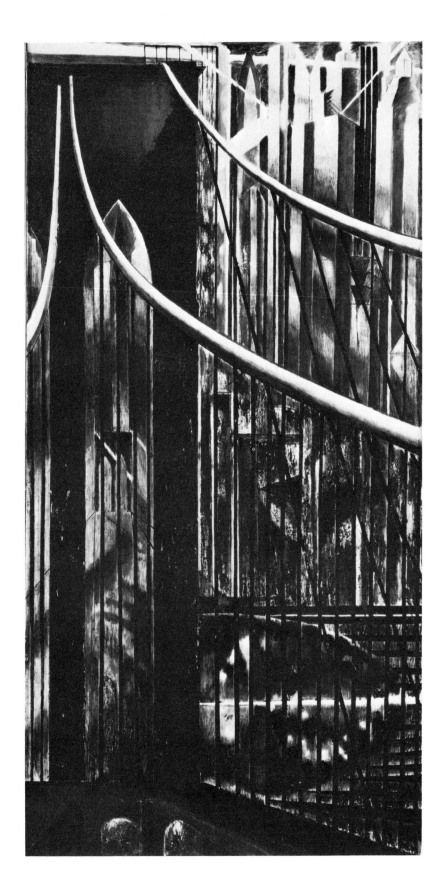

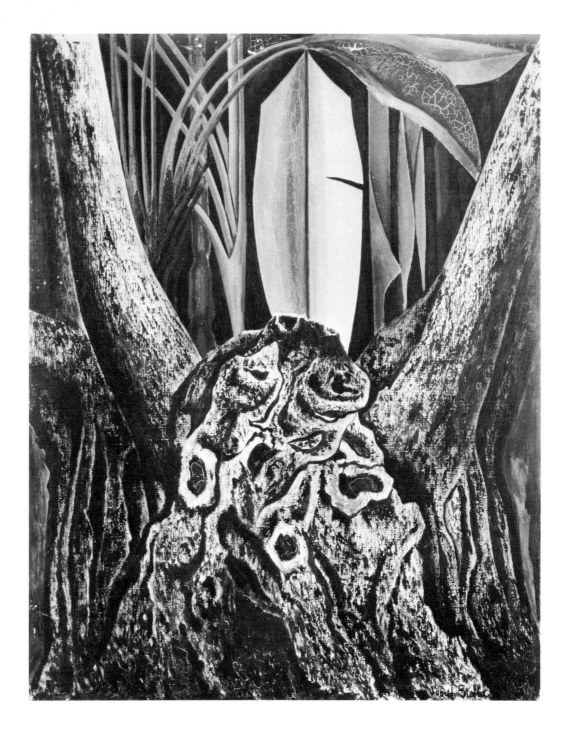

Opposite

86. *American Landscape.* 1929. Oil. 78 x 39 inches.
Walker Art Center, Minneapolis, Minnesota.

87. *Forest Cathedral.* 1930. Oil. 46¼ x 37⅜ inches.
Collection of the Estate of Joseph Stella.

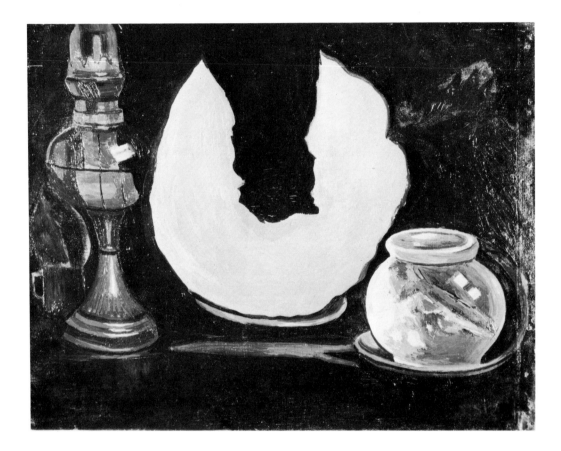

88. *Still Life with Yellow Melon*. 1929. Oil. 15 x 18⅞ inches.
Rabin and Krueger Gallery, Newark, New Jersey.

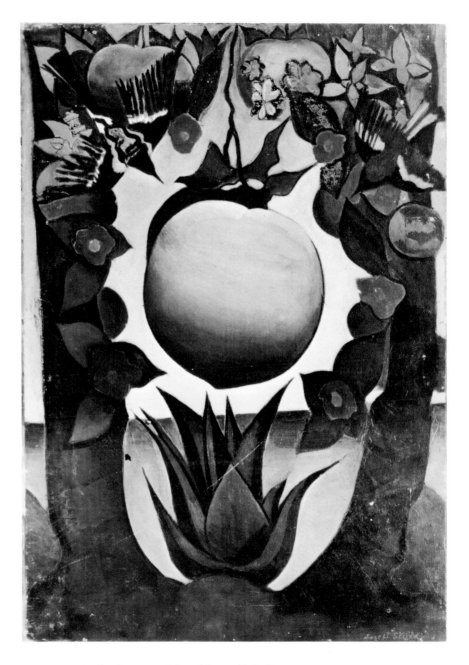

89. *Green Apple. Ca.* 1930. Oil. 30¼ x 21¼ inches.
Collection of the Estate of Joseph Stella.

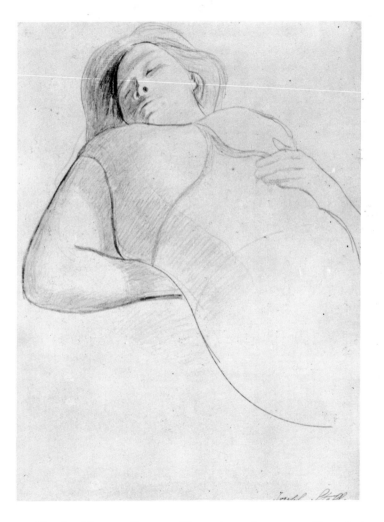

90. *Sleeping Woman. Ca.* 1932. Silverpoint and crayon. 11¾ x 9 inches (sight).
Collection of Ira Moskowitz, New York.

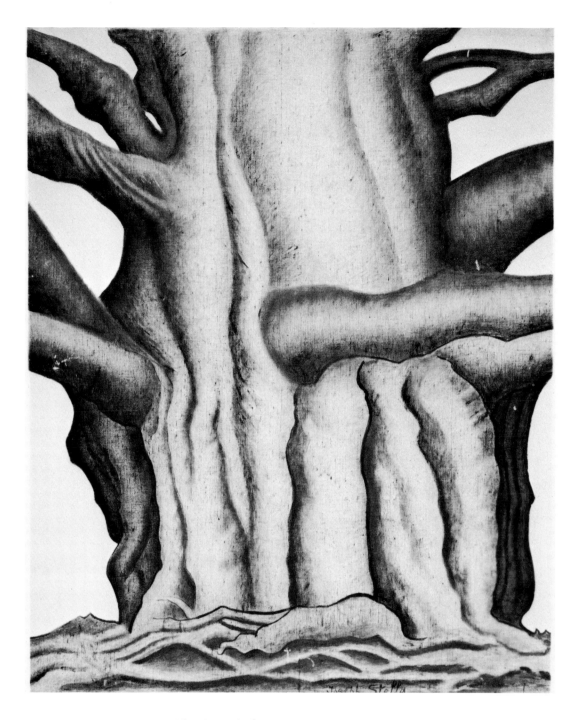

91. *Banyan Tree. Ca.* 1938. Oil. 36 x 31 inches.
Collection of the Estate of Joseph Stella.

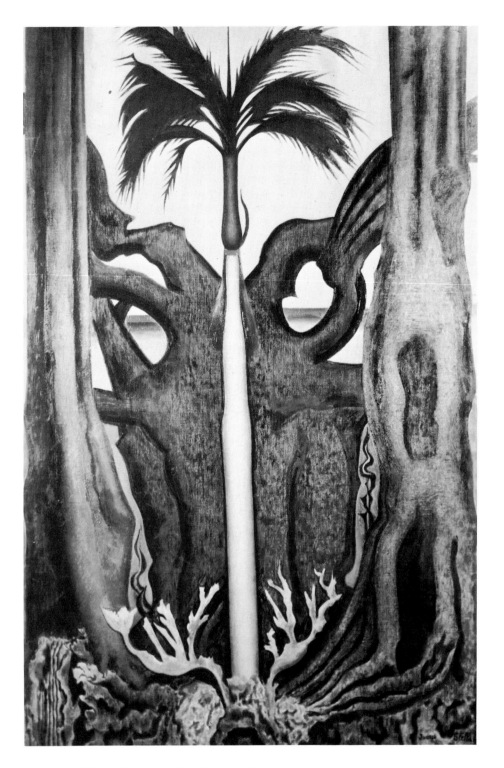

92. *Song of Barbados*. 1938. Oil. 58 x 37 inches.
Rabin and Krueger Gallery, Newark, New Jersey.

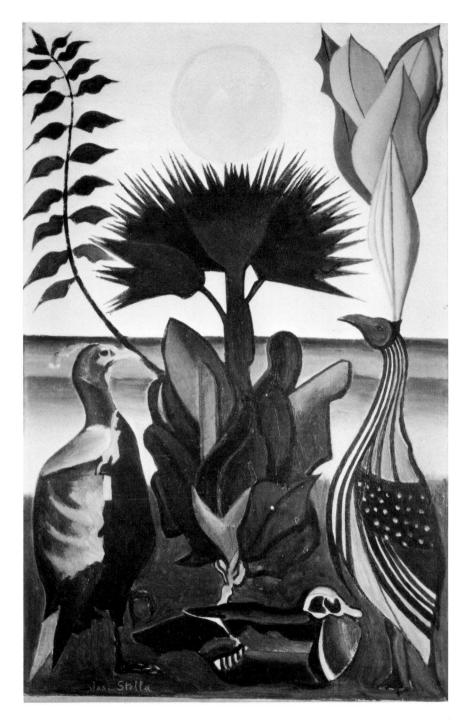

93. *Full Moon (Barbados)*. 1940. Oil. 36 x 25 inches.
Collection of Sergio Stella, Glen Head, New York.

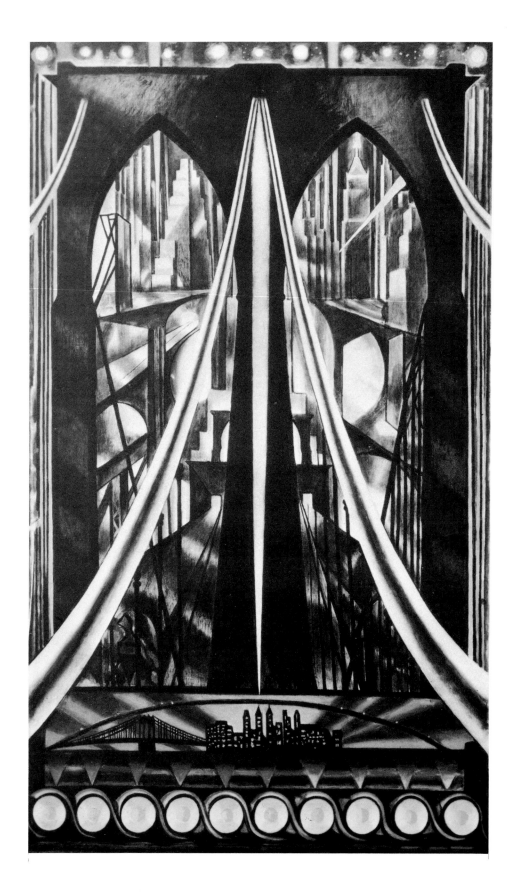

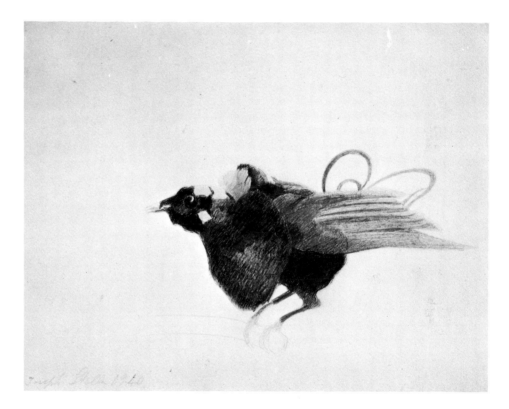

Opposite

94. *Brooklyn Bridge: Variation on an Old Theme.* 1939. Oil. 70 x 42 inches.
Whitney Museum of American Art, New York.

95. *Tropical Bird.* 1940. Crayon. 7⅛ x 9½ inches (sight).
Collection of Samuel L. Denburg, Newark, New Jersey.

Below

96. *Still Life.* 1944. Oil and gouache on paper. 28 x 21 inches. Collection of Dr. and Mrs. Leonard M. Weinstock.

97. *Still Life with Small Sculpture.* 1944. Pencil and crayon. 14 x 13½ inches. Collection of Mr. and Mrs. John D. Frisoli, Short Hills, New Jersey.

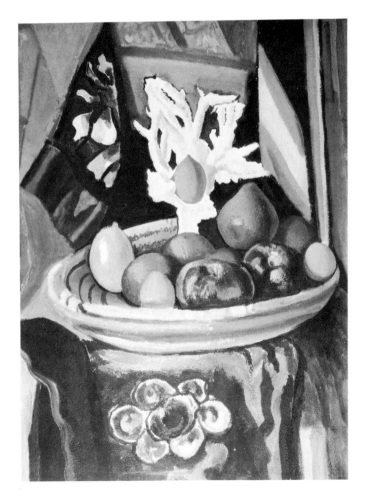

CHRONOLOGY

SELECTED BIBLIOGRAPHY

INDEX

CHRONOLOGY

1877 June 13, Joseph Stella born in Muro Lucano, a medieval mountain village near Naples. Educated in Muro Lucano and Naples.

1896 March 1, arrives in New York on S.S. *Kaiser Wilhelm der Grosse,* sponsored by his brother Dr. Antonio Stella, eminent physician and leader in Italo-American affairs in New York, especially concerned with problems of the immigrants.

1896–97 Studies medicine and pharmacology, each about one year.

1897 Gives up medical studies for painting. Enrolls at Art Students League.

1898–1900 Attends the New York School of Art, where he comes to the attention of William Merritt Chase. After one year he wins a scholarship to attend a second year.

1900–1905 Lives on Lower East Side, in the Bowery section. Constant sketching of immigrant types, picturesque and tragic subjects seen on the streets of New York. December 23, 1905, Stella's first published drawings appear in *Outlook,* illustrations for "Americans in the Rough," depicting immigrants at Ellis Island.

1906 Illustrations for Ernest Poole's novel *The Voice of the Street,* probably done in 1905, as the book was published in 1906.

1907 To West Virginia. Drawings for *Survey* of the Monongah mine disaster appear in the issue of December 6.

1908 To Pittsburgh. Drawings of the mining environment appear in *Survey* for January, February, and March, 1909.

1909 Either in this year, or possibly 1910, makes his first trip back to Europe. Spends the first year or so in Italy, mostly in Rome, Florence, and Muro Lucano, although he may have traveled to Venice. Is friendly with Mancini in Rome.

1911–12 In Paris. Meets Matisse, Modigliani, Carrà, and probably Boccioni and Severini among others of the avant-garde artists. Returns to New York.

1913 Exhibits two or three paintings in the Armory Show. Has a one-man exhibition at the Italian National Club, 11 West 44th Street, New York.

1914 Participates in the exhibition of modern art at the Montross Gallery, where his painting *Battle of Lights, Coney Island* provokes public derision but wins critical respect in advanced quarters.

1915 Meets Marcel Duchamp, Picabia, Edgard Varèse, and other artists, writers, and musicians who frequented the home of Walter Arensberg.

1916–17 Moves to Brooklyn, where he teaches Italian at a Baptist seminary in Williamsburg.

1918 To Pittsburgh and Bethlehem. Illustrations for *Survey* of industrial subjects depicting the war effort.

1919 Exhibits *The Gas Tank* (under the title of *American Landscape*), the first of his major industrial paintings to be shown, at the Bourgeois Galleries.

1920 First *Brooklyn Bridge* exhibited in his one-man show at the Bourgeois Galleries. Living at 213 West 14th Street. Joins the newly formed Société Anonyme, whose directors were Katherine Dreier, Marcel Duchamp, and Man Ray. Participates in exhibitions of the Société Anonyme in the 1920's.

1922 Trip to Naples. Visits Pompeii, Herculaneum, Paestum, Capri.

1923 Returns to New York. Lives at 451 West 24th Street. January 10, opening of the exhibition at the Société Anonyme, where *New York Interpreted* is shown for the first time. August 30, admitted to United States citizenship.

1926 Travels to Europe. In Naples in September. Possibly visits North Africa.

1928 In New York, living at 218 East 12th Street. Returns to Europe, this time first to Paris.

1929 Trip to Naples, January to June. Also probably visits North Africa. Returns to Paris. Sometime during 1929 is on the Riviera, possibly near Nice.

1930–34 Lives in Paris, first at 16 rue Boissonade, until late 1933, when he moves to 201 rue d'Alésia. Probable trips to Italy and North Africa during these years.

1934 February, Stella in Rome during the International Exhibition of Religious Art, in which he shows twelve paintings.

1935 In New York, possibly having returned the previous year. Lives at 2431 Southern Boulevard, the Bronx.

1937 Studio at 322 East 14th Street. December, leaves for Barbados, where he spends several months.

1938 Travels to Europe. In Paris at 39 Boulevard Edgar Quinet. July 28, in Venice. September, in Naples. By December is back in New York, living at 322 East 14th Street.

1942 Moves to 13 Charlton Street in April. Gives up studio because of illness and moves to apartment near nephew in Astoria at 33–15 Crescent Boulevard.

1943 Takes studio at 104 West 16th Street. Suffers thrombosis in left eye and returns to Astoria.

1945 Suffers accident while serving on jury of "Third Portrait of America" exhibition.

1946 November 5, Joseph Stella dies.

ONE-MAN EXHIBITIONS

1910 Carnegie Institute (drawings), also shown in Chicago and New York.

1913 Italian National Club, New York.

1920 Bourgeois Galleries, New York (oils, watercolors, pastels, drawings, silverpoints, retrospective).

1923 Société Anonyme, New York.

1924 Dudensing Gallery, New York.

1926 The New Gallery, New York; Valentine Gallery, New York (also 1928, 1931, 1935); City Library Gallery, Des Moines Association of Fine Arts.

1929 Angiporto Galleria, Naples, Italy.

1930 Galerie Sloden, Paris, France.

1932 Washington Palace, Paris, France.

1935 Valentine Gallery, New York.

1937 Cooperative Gallery, Newark.

1939 The Newark Museum (retrospective).

1941 Associated American Artists, New York.

1942 M. Knoedler and Company, New York.

1943 A.C.A. Gallery, New York.

1958 Zabriskie Gallery, New York, also 1959, 1960, 1961 (collages).

1960 The Museum of Modern Art (drawings), circulating exhibition.

1962 Contemporary Paintings, Buffalo.

1963 Whitney Museum of American Art, New York (retrospective).

1963 Robert Schoelkopf Gallery, New York, also 1964 (drawings).

1963 Harry Salpeter Gallery, New York.

1964 Seton Hall University, South Orange, New Jersey.

1966–67 Galleria Astrolabio Arte, Rome, Italy.

1968 University of Maryland Art Gallery, College Park, Maryland.

SELECTED BIBLIOGRAPHY

IRMA B. JAFFE

This bibliography is arranged in three parts. Part I lists critical reviews of exhibitions, signed articles, books, and catalogues that contain more than passing reference to Stella. Part II consists of unsigned or routine notices and other brief references in periodicals, and Part III of one-man exhibition catalogues. Newspaper notices and biographical dictionaries are not included.

PART I

ANTIN, MARY. "They Who Knock at Our Gates." *American Magazine* (April 18, 1914), pp. 18ff. (Also published in book form, same title, Boston: Houghton Mifflin, 1914, but with some illustrations omitted.)

Armory Show Fiftieth Anniversary, 1913–1963. New York: Henry Street Settlement; and Utica, N.Y.: Munson-Williams-Proctor Institute, 1963.

ARTIERI, GIOVANNI. "Cronache." *Emporium,* 69 (June, 1929), 377.

BAKER, ELIZABETH C. "The Consistent Inconsistency of Joseph Stella." *Art News* (December, 1963), pp. 46–68.

BAUR, JOHN I. H. *Joseph Stella.* Exhibition catalogue. New York: Shorewood, 1963.

——. "Joseph Stella Retrospective." *Art in America* (November 5, 1963), pp. 32–37.

——. "The Machine and the Subconscious: Dada in America." *Magazine of Art,* 44 (October, 1951), 233.

——. *Revolution and Tradition in Modern American Art.* Cambridge, Mass.: Harvard University Press, 1951.

——, ed. *New Art in America.* Greenwich, Conn.: New York Graphic Society, in cooperation with Frederick A. Praeger, New York, 1957.

BLESH, RUDI. *Modern Art U.S.A.* New York: Alfred A. Knopf, 1956.

BROOK, ALEXANDER. "February Exhibitions." *The Arts,* 3 (February, 1923), 127.

Brooklyn Museum. *Brooklyn Bridge. Seventy-Fifth Anniversary Exhibition.* Brooklyn, N.Y.: The Brooklyn Museum, 1958.

BROWN, MILTON W. *American Painting from the Armory Show to the Depression.* Princeton, N.J.: Princeton University Press, 1955.

——. "Cubist Realism." *Marsyas,* Nos. 3–4 (1943–47), 139–58.

——. *The Story of the Armory Show.* Joseph H. Hirshhorn Foundation, 1963, distributed by New York Graphic Society, Greenwich, Conn.

CAHILL, HOLGER. *A Museum in Action.* Catalogue of American paintings and sculpture from the museum's collections. Newark, N.J.: The Newark Museum, 1944.

CHANIN, A. L. *Art Guide/New York.* New York: Horizon Press, 1965.

CHENEY, SHELDON. *A Primer of Modern Art.* New York: Boni and Liveright, 1924.

City Art Museum of St. Louis. *Two Hundred Years of American Painting.* Exhibition catalogue. St. Louis, 1964.

Collection of the Société Anonyme: Museum of Modern Art 1920. New Haven, Conn.: Yale University Art Gallery, 1950.

CRAVEN, THOMAS. "Joseph Stella." *Shadowland,* 7 (January, 1923), 11.

DREIER, KATHERINE S. *Modern Art.* New York: Société Anonyme, 1926.

————. *See* Yale University Sterling Library.

————. *Western Art and the New Era: An Introduction to Modern Art.* New York: Brentano's, 1923.

ELIOT, ALEXANDER. *Three Hundred Years of American Painting.* New York: Time, Inc., 1957.

FIELD, HAMILTON. "Joseph Stella." *The Arts,* 9 (October, 1921), 24–27.

————. "Joseph Stella." Unpublished monograph. New York, 1939.

————. "Joseph Stella, genio del color." *Social* (Havana, Cuba, July, 1928), pp. 43–46.

FREUND, FRANK E. W. "Joseph Stella." *Der Cicerone,* 16 (October, 1924), 963–72. (Reprinted in *Jahrbuch der jungen Kunst,* Leipzig, 1924, pp. 310ff.)

FRIEDMAN, MARTIN L. *The Precisionist View in American Art.* Exhibition catalogue. Minneapolis, Minn.: Walker Art Center, 1960.

GAYLOR, WOOD. Untitled autobiographical manuscript transcribed from a series of tape recordings. Mimeographed copy in the library of the Whitney Museum of American Art, New York.

GELDZAHLER, HENRY. *American Painting in the Twentieth Century.* New York: The Metropolitan Museum of Art, 1965.

GERDTS, WILLIAM. *Drawings of Joseph Stella.* Newark, N.J.: Rabin and Krueger Gallery, 1962.

————. "People and Places of New Jersey." *Newark Museum Bulletin,* n.s. 15 (Spring–Summer, 1963), 36.

GOODRICH, LLOYD. *The Decade of the Armory Show 1910–1920.* New York: Whitney Museum of American Art, 1963.

————. *Pioneers of Modern Art in America.* New York: Frederick A. Praeger, 1962.

GOODRICH, LLOYD, and BAUR, JOHN I. H. *American Art of Our Century.* New York: Frederick A. Praeger, 1961.

HAFTMANN, WERNER. *Painting in the Twentieth Century.* New York: Frederick A. Praeger, 1960.

HUNTER, SAM. *American Modernism: The First Wave.* Exhibition catalogue. Waltham, Mass.: Brandeis University, The Poses Institute of Fine Arts, 1963.

————. *Modern American Painting and Sculpture.* New York: Dell Publishing Co., 1959.

JAFFE, IRMA B. *Joseph Stella.* Cambridge, Mass.: Harvard University Press, 1970.

————. "Joseph Stella: An Analysis and Interpretation of His Art." Unpublished Ph.D. dissertation, Columbia University, 1966.

————. "Joseph Stella and Hart Crane: The Brooklyn Bridge," *The American Art Journal,* 1 (Fall, 1969), 98–107.

KOUWENHOVEN, JOHN A. *American Studies: Words or Things?* Wilmington, Del.: The Wemyss Foundation, 1963.

LANCELLOTTI, A. "Un Pittore di Avanguardia: Giuseppe Stella." *Emporium,* 71 (February, 1930), 67–76.

LARKIN, OLIVER W. *Art and Life in America.* New York: Rinehart and Co., 1949.

LENFEST, MARIE. "Joseph Stella—Immigrant Futurist." Unpublished Master's thesis, Columbia University, 1959.

LOVING, PIERRE. "Joseph Stella—Extremist." *The Nation,* 116 (April 11, 1923), 446.

MCBRIDE, HENRY. "Modern Art." *The Dial,* 73 (April, 1923), 423–25.

————. "Modern Art." *The Dial,* 80 (June, 1926), 525–27.

MELLQUIST, JEROME. "Les Courants de la Peinture Americaine." *Les Arts Plastiques* (February–March, 1952), pp. 271–8.

————. *The Emergence of an American Art.* New York: Charles Scribner's Sons, 1942.

Museum of Modern Art. *Art in Progress.* New York, 1944.

————. Artists File: "Joseph Stella."

New York Public Library. Artists File: "Joseph Stella."

OERI, GEORGINE. "The Object of Art," *Quadrum* (November 16, 1964), pp. 7–8.

PACH, WALTER. "The Point of View of the 'Modernist.' " *The Century,* 87 (April, 1914), 851–68.

PARKER, EDWIN S. "Analysis of Futurism." *International Studio,* 58 (April, 1916), 59.

POOLE, ERNEST. *The Voice of the Street.* New York, A. S. Barnes, 1906.

PORPORA, ANTONIO. "Giuseppe Stella: un pittore futurista di Basilicata a New York." *Italiani pel Mondo* (September, 1926), pp. 226–30.

PUTNAM, SAMUEL. *Paris Was Our Mistress.* New York: Viking Press, 1947.

RILEY, MAUDE. "Stella in Review." *Art Digest,* 18 (November 15, 1943), 13.

RITCHIE, ANDREW C. *Abstract Painting and Sculpture in America.* New York: The Museum of Modern Art, 1951.

ROSENBLUM, ROBERT. *Cubism and Twentieth Century Art.* New York: Harry N. Abrams, 1960.

SALPETER, HARRY. "Stella: Art's Poetic Gladiator." *Esquire,* 16 (July, 1941), 92, 107.

SANTORO, FERDINANDO. "Giuseppe Stella." *Italiani pel Mondo* (August, 1928), pp. 803–11.

————. "Preview of Stella exhibition, Angiporto Galleria, Naples, 1929." *Italiani pel Mondo* (March–April, 1929), pp. 333–34.

SCHETTINI, ALFREDO. *Vita di Antonio Mancini.* Naples: Editrice Rispoli Anonima, 1941.

STELLA, JOSEPH. "The Brooklyn Bridge (A Page of My Life)." *Transition,* 16–17 (June, 1929), 86–88. This essay was previously printed and distributed privately by Stella, in brochure form, with illustrations of the five sections of *New York Interpreted.*

————. "Confession." *The Little Review* (Spring, 1929), pp. 79–81.

————. "Discovery of America: Autobiographical Notes." *Art News,* 59 (November, 1960), 41–43, 64–67. Written in 1946.

————. "The New Art." *The Trend* (June, 1913), pp. 392–95.

————. "On Painting." *Broom,* I (December, 1921), 119–23.

TORREY, ARTHUR H. "A Gift from Mr. Lewisohn." *Brooklyn Museum Quarterly,* 15 (October, 1928), 117.

TRACHTENBERG, ALAN. *Brooklyn Bridge: Fact and Symbol.* New York: Oxford University Press, 1965.

TYRRELL, HENRY. "New York in Epic Painting." *Il Carroccio,* 17 (March, 1923), 351.

VON WIEGAND, CHARMION. "Joseph Stella, Painter of Brooklyn Bridge." Unpublished essay, 1939.

WEBER, BROM. *Hart Crane.* New York: Bodley Press, 1948.

Whitney Museum of American Art. Artists File: "Joseph Stella."

WILLIAMS, HELEN. "The Art of Joseph Stella in Retrospect." *International Studio,* 84 (July, 1926), 76–80.

Yale University. *Collection of the Société Anonyme.* New Haven: Yale University Art Gallery, 1950.

Yale University Fine Arts Library. "Société Anonyme."

Yale University Sterling Library. American Collection: "Joseph Stella Correspondence."

PART II

Art Digest, 5 (August, 1931), 9.
————, 6 (December 1, 1931), 15.
————, 9 (January 15, 1935), 8.
————, 12 (November 15, 1927), 29.
————, 13 (July 1, 1939), 11.
————, 15 (January 15, 1941), 18.
————, 16 (May 1, 1942), 15.
————, 20 (April 15, 1946), 7.
Art News, 4 (March 24, 1906), 2.
————, 20 (November, 1921), 10.
————, 26 (February 4, 1928), 9.
————, 28 (June 14, 1930), 23.
————, 30 (November 28, 1931), 25.
————, 33 (January 12, 1935), 11.
————, 39 (January 11, 1941), 13.
————, 41 (May 15, 1942), 21.
————, 42 (November 15, 1943), 21.
————, 45 (April, 1946), 35.
————, 58 (September, 1959), 10.
————, 60 (November, 1961), 15.
————, 61 (February, 1963), 10.
————, 63 (October, 1964), 12.
Arts, 32 (May, 1958), 55.
————, 36 (October, 1961), 40.
————, 37 (February, 1963), 50.
————, 38 (December, 1963), 65.
————, 39 (October, 1964), 23.
————, 39 (November, 1964), 60.
Bulletin and Italiana (Italy America Society), 2 (May, 1928), 90.
Der Cicerone, 12 (1920), 450.
————, 14 (1922), 50.
Current Opinion, 64 (June, 1918), 423.
————, 68 (June, 1920), 832.
Italy American Monthly, 2 (April 25, 1935), 14.
The Little Review (Autumn, 1922); special Stella number.
Logique (Paris, March 30, 1934), p. 11.
The New Yorker (April 18, 1925), p. 17.
————. (April 23, 1926), p. 49.
————. (April 14, 1928), p. 82.
————. (December 12, 1931), p. 57.
Pictures on Exhibit (October, 1963), p. 4.
Time (November 8, 1963), p. 70.
The Trend, 5 (May, 1913), 208.

PART III

(*in chronological order*)

Retrospective Exhibition of Paintings, Pastels, Drawings, Silverpoints and Watercolors by Joseph Stella. New York: Bourgeois Galleries, March 27–April 24, 1920.

Joseph Stella, Encaustic Paintings. New York: The New Gallery, April 16–May 1, 1926.

Exhibition of Paintings by Joseph Stella. Des Moines, Iowa: City Library Gallery, Des Moines Association of Fine Arts, May 9–June 1, 1926.

Mostra di Arte del Pittore Giuseppe Stella. Naples: *Italiani pel Mondo* (Angiporto Galleria), 1929; preface by FERDINANDO SANTORO.

Joseph Stella, Peintures, Aquarelles, Pointes d'Argent. Paris: Galerie Sloden, May 7–31, 1930.

Exhibition of Paintings by Joseph Stella. New York: Valentine Gallery, January 7–26, 1935.

Joseph Stella, Recent Paintings and Drawings. Newark, New Jersey: Cooperative Gallery, December, 1937.

Joseph Stella, A Retrospective Exhibition. Newark, New Jersey: The Newark Museum, April 22, 1939; preface by ARTHUR F. EGNER.

Joseph Stella. New York: M. Knoedler and Company, April 27–May 16, 1942; preface by HENRY McBRIDE.

Stella. New York: A.C.A. Gallery, November 8–27, 1943; preface by KATHERINE DREIER; essay by JOSEPH STELLA.

Joseph Stella. New York: Zabriskie Gallery, April 15–May 17, 1958; preface by MILTON W. BROWN.

Portraits by Joseph Stella. New York: Zabriskie Gallery, September 14–October 3, 1959.

Joseph Stella. New York: Zabriskie Gallery, November 14–December 10, 1960; preface by ROBERT J. SCHOELKOPF, JR.

Collages of Joseph Stella. New York: Zabriskie Gallery, October 2–October 28, 1961.

Joseph Stella. New York: Whitney Museum of American Art, 1963.

Joseph Stella. New York: Robert Schoelkopf Gallery, January 2–February 5, 1963.

Joseph Stella. New York: Robert Schoelkopf Gallery, October 29–November 16, 1963.

Joseph Stella. New York: Harry Salpeter Gallery, November, 1963.

Drawings of Joseph Stella. New York: Robert Schoelkopf Gallery, October, 1964.

Joseph Stella. Mountainville, New York: Storm King Art Center, n.d.

Stella. South Orange, New Jersey: Seton Hall University, November–December, 1964.

Joseph Stella. Rome, Italy: Galleria Astrolabio Arte, December 1966–January, 1967.

Joseph Stella. College Park, Maryland: University of Maryland Art Gallery. September–October, 1968.

INDEX

Design by Joseph Bourke Del Valle.

Black-and-white illustrations and text printed by
 Halliday Lithograph Corp.

Color plates lithographed by Sale-Niagara Co.

Typefaces are Granjon and Michaelangelo Titling.

Composition by Harry Sweetman Typesetting Corp.